hook, yarn AND crochet

20 CUTE AND QUIRKY CROCHET PROJECTS

Ros Badger

Quadrille
PUBLISHING

Photography by Keiko Oikawa

Contents

hook, yarn, AND crochet

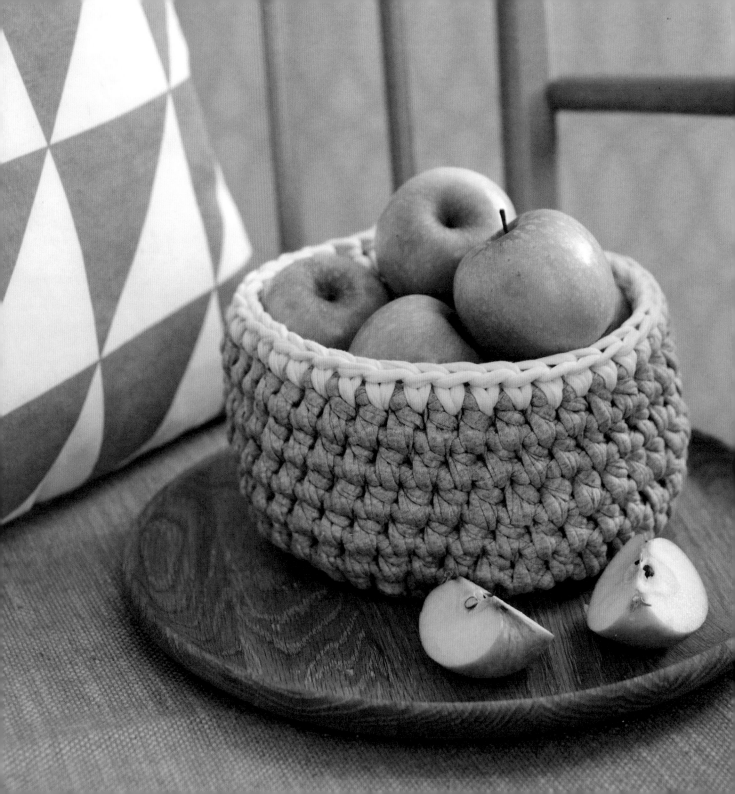

Introduction

Not since the 1970s has crochet been so popular across all generations. No longer overshadowed by the maker's obsession with knitting, crochet is experiencing a renaissance. In the last two years, trends have changed, crochet is back, stronger than ever, as we all recognise its inherent beauty as a craft.

Today's fashion and interior design trends are far more eclectic than they were 40 years ago. In this book I have created over 20 projects with a timeless quality – crochet pieces for the home, pieces you could give as gifts, and stylish designs to wear.

My enthusiasm for the craft began when I was eight years old and my grandmother taught me how to crochet. I already knew the basics of sewing but I hadn't been taught how to knit at that stage. Mary Elizabeth passed on her knowledge to me and from that day I was hooked. Then in her sixties, she would make a hooded shawl for every new baby that was born, whether family, friends or neighbours! I was fascinated by how quickly her work grew and could see how lovely it would be if I could make something for my dolls that was different to anything else they owned. Within three days of being shown the basics and having taken my work to school with me to work on in my lunchtime, I had finished my first blanket. I placed it on my doll's cot and I still have it today, 40 years later.

I studied textiles at Chelsea College of Art in London, where I specialised in knitting, but I have always included crochet in my work. In the late '80s and '90s, when I was a freelance designer making cotton bags for Margaret Howell or hats for Fred Bare and Duffer of St George, among others, I always used crochet as well as knitting. Later, when designing accessories for my children's range Little Badger, I included a crochet bonnet and bootees, which I still produce today.

The projects for this book were a joy to make. I rediscovered the satisfaction of creating something that can be completed in an afternoon or evening, and I was able to explore new stitch textures and use yarns that I had no previous experience of. The re-cycled cotton jersey with which I made the Storage Basket on pages 80–81 was a great find and something I would love to create with again. I also delighted in the diversity that I was able to bring to the designs, from a delicate mercerised cotton Shells Collar on page 46–49, traditional and retro in style, to a robust Jute Shopper on pages 64–67 and practical string Pot Stand on pages 74–75, the ridged stitch of which uses the simple yet effective technique of working into the back loop of each stitch. I also felt inspired designing the small playful makes – the Daisy Chain on pages 102–105, the Star Garland on pages 112–115 and the cute big-eared Bunny Toy on pages 106–111.

The best thing about this book was being able to combine interior pieces with wearable designs. One day I would be crocheting a lampshade cover and the next day wrist warmers. I spent three months designing and crocheting every day. I relished every minute of the process and hope that you will enjoy your journey through this book as much as I enjoyed making it.

Ros.

Materials

Unlike some other crafts that require lots of specialist equipment or heavy machinery, the only piece of kit that is absolutely essential for crochet is the hook. It is available in a variety of materials – such as aluminium, steel, plastic and bamboo – as well as sizes. Choose the crochet hook that feels most comfortable in your hand. The smallest steel hooks designed for intricate lacework start at 0.75mm and go up to 3.5mm. The most commonly used hooks start at size 3.5mm and go up to 10mm, but even larger plastic and wooden hooks are available for supersized crochet.

The constituent parts of a crochet hook are the tip, throat, shank, grip and handle. The rounded tip allows the hook to pass through smoothly when inserted into a stitch or space. Sitting just below the tip, the throat of the hook is the crook that catches the working yarn. The shank is the part of the hook that determines the size of the stitches being worked; the size of the hook relates to the diameter of the shank. The grip is where you place your thumb and forefinger, depending on which method you use to hold the hook (see page 13), with the rest of the handle helping to maintain the overall balance of the hook.

A hook's size correlates to the diameter measurement taken around the shank. In the UK, this is given in millimetres. When checking a hook using a size gauge, the shank should fit snugly into the correct size hole. Measurements do vary slightly depending on the manufacturer, so it is always sensible to crochet and measure a tension swatch (see page 30) before beginning a project to ensure you are using the correct size hook.

HOOK SIZES

Metric	UK	Imperial US
2mm	14	4 steel
2.25mm	13	B/1
2.5mm	12	1/0
2.75mm	11	C/2
3.25mm	10	D/3
3.5mm	9	E/4
3.75mm		F/5
4mm	8	G/6
4.5mm	7	7
5mm	6	H/8
5.5mm	5	I/9
6mm	4	J/10
6.5mm	3	K/10½
7mm	2	
8mm	0	L/11
9mm	00	M,N/13
10mm	000	N,P/15

OTHER USEFUL THINGS
TO HAVE TO HAND WHEN
CROCHETING

Tape measure, for checking tension

Scissors, for snipping yarns

Blunt-ended yarn needle or tapestry needle, for stitching bits together and weaving in yarn ends

Pins, for pinning stuff together

Steam iron, for finishing and pressing

Basic techniques

HOW TO READ A CROCHET PATTERN

It is one thing knowing all the basic crochet stitches, but they aren't really of any use unless you know how to work through a pattern and bring all the techniques together.

Without some guidance, it can be a struggle to understand what the jumble of letters and numbers mean. A handy list of what all the common abbreviations stand for certainly helps (see inside back-cover flap), but there are other essential pieces of information that you still need to know to be able to decode a pattern.

2 The first stitches to work are the beginning chain stitches that set up the row or round. The instructions will also tell you whether or not the chains are to be counted as your first stitch within your overall stitch count. These chains are worked to make sure that the first stitch of the row or round is going to be worked at the same height as the rest of the stitches.

1 The first word of a line of instruction lets you know whether you are working the stitches in a straight row or in a round.

Round 2: 1 ch (does NOT count as a stitch), next dc ** , 1 dc in each of next 3 dc; rep from 1 dc in next dc, join with a sl st in top of first

6 The instruction 'join' is usually used when working in the round and means you need to join the first and last stitches in the round with a slip stitch.

How to work from a stitch diagram

Increasingly, crochet patterns are being presented in the form of diagrams made up of a series of symbols. At first, these stitch charts can look like impenetrable technical drawings, but once you are familiar with the symbols they give an immediate visual impression of what the finished crochet piece will look like.

SYMBOLS

- • = slip stitch
- ○ = chain stitch
- + = double crochet
- T = half treble crochet

- T = treble crochet
- = double treble
- = triple treble

3 The next instructions tell you to work one double crochet stitch into the stitches or chains in the preceding row or round.

4 The brackets indicate that the instructions sitting inside the brackets are to be repeated the number of times directly after the closing bracket or into the stitch specified.

**1 dc in first 2 dc, *[1 dc, 9 ch, 1 dc] all in
* 3 times more and from * to ** once,
dc at beginning of round. (Five 9-ch loops)**

5 An asterisk means that the instructions that follow are then repeated by the number of times stated or to the end of the row/round.

7 The stitch counts given after the instructions tell you how many stitches you should have worked in that specific row/round.

STARTING WITH A SLIP KNOT

In order to start crocheting you need to have a starting stitch on the crochet hook. This is made by making a slip knot, which is the first stitch of either a foundation chain for working in rows or a base ring for working in the round. When making a slip knot, whether for a foundation chain or a base ring, you only need to leave a short tail of yarn. When counting stitches, the slip knot always counts as the first 'cast-on' stitch.

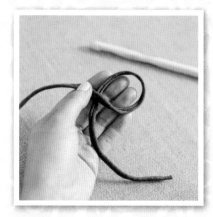

1 Leaving a tail end of yarn of approximately 10cm (4in) long, curl the yarn into a loop in your left hand.

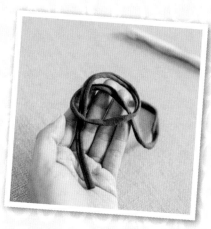

2 Drag the working (ball) end of the yarn back across and behind the loop already made.

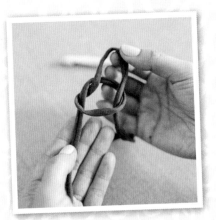

3 With your right hand, pick up the strand of the yarn in the centre of the loop and lift it through the loop.

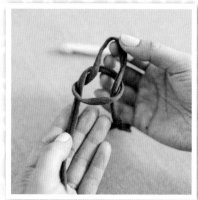

4 Slide your crochet hook into this new loop and pull gently on both ends of the yarn to tighten the slip knot just formed. You may now continue to make a foundation chain or a base ring as given on pages 14 and 26.

HOLDING THE HOOK AND YARN

Finding a comfortable working position takes practice but it is worth spending the time to get the basic technique right. The way you hold the yarn determines whether or not it flows easily with the correct tension, which is important for creating a neat and even fabric. One hand holds the crochet hook while the other holds the yarn and plays the important role of tensioning the yarn – essential for achieving an even tension. Whether you are right- or left-handed, the technique is the same.

You can hold the hook in one of two ways, so go with whichever feels more comfortable. But do not hold the hook too tightly or too close to the tip. Try holding the crochet hook as if it were a pencil or, alternatively, hold the crochet hook as if it were a knife, in the palm of your hand as shown below.

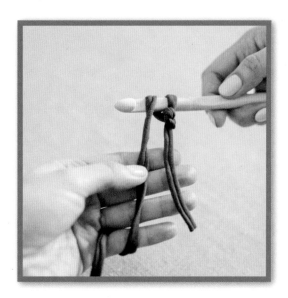

1 Leaving a length of yarn approximately 10cm (4in) from the loop on the hook, wrap the yarn around your little finger and across your two middle fingers.

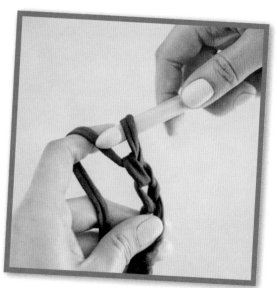

2 Then take the yarn behind your index finger and over to the front, leaving it to rest on your elevated index finger. Use your second finger and thumb to pull gently on the yarn or chain just below the hook to tension the yarn.

MAKING A FOUNDATION CHAIN

Abbreviation:
ch

The base of all crochet is invariably a length of chain stitches, so learn this stitch first. Chains are also used to take the hook up to the correct height at the end of one row in preparation for the next. It is important to keep the tension of a chain even, so the stitches are neither too tight nor too loose.

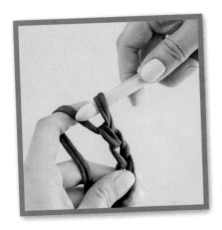

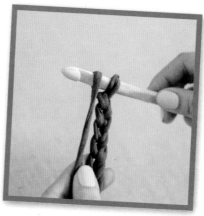

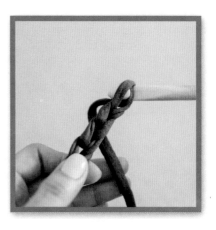

1 Place a slip knot on the neck of the hook and hold the yarn, keeping a good tension on the tail end of the yarn by holding the base of the slip knot between your thumb and second finger.

2 Pass the hook from left to right under the yarn elevated by your index finger and around the yarn in an anticlockwise movement to catch the yarn in the crook of the hook. This is called 'yarn round hook' (yrh) and is one of the most important parts of creating any stitch.

3 Draw the yarn caught in the crook of the hook through the slip knot or the loop already on the hook. Keep the yarn under tension at all times. As you draw the yarn through, rotate the hook so that the crook is facing downwards. You have now made one new chain (ch).

4 Repeat step 2 and 3 to create more chain stitches. Remember, you will need to reposition the tensioning fingers every four or five of stitches to maintain a good tension on the yarn.

COUNTING CHAINS

When working from any pattern you will need to make a given number of chains to create the foundation chain. In order to count the chains accurately, it is important to be able to recognise the formation of each chain.

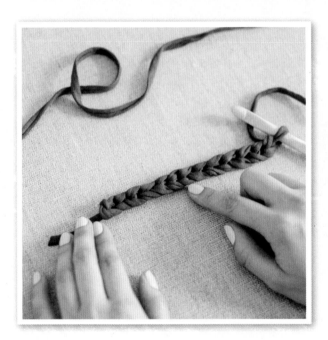

The front of a chain

The front of the chain looks like a series of V shapes made by the yarn. Each V is a chain loop sitting between two other chain loops. The first chain made will have the slip knot sitting directly before it. The surface of the chain is smooth on this front side. Stitches should be counted from this side of the chain wherever possible.

The reverse of a chain

The reverse of the chain has a row of bumps that have been created by the yarn. These bumps sit behind the V and run in a straight line from the slip knot to the hook. The surface of the reverse of the chain is more textural than the front side.

Counting chains

When counting chains, do not include the stitch on the hook. This is because, at all times, a loop remains on the hook up to the point where you fasten off. To make counting chains easier when working a large number of chains, it is a good idea to place stitch markers at predetermined intervals, such as after every 10 or 20 stitches.

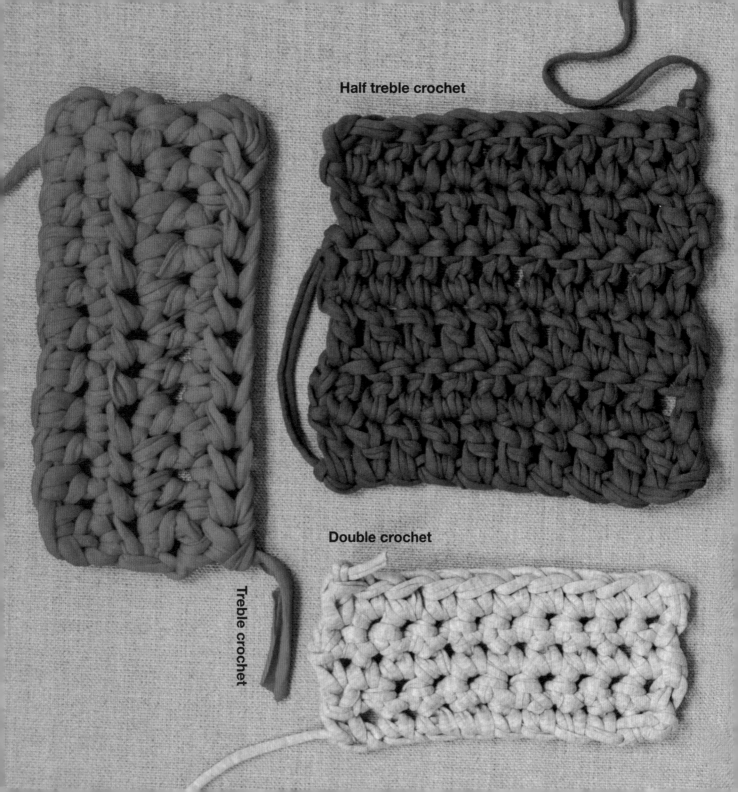

Half treble crochet

Double crochet

Treble crochet

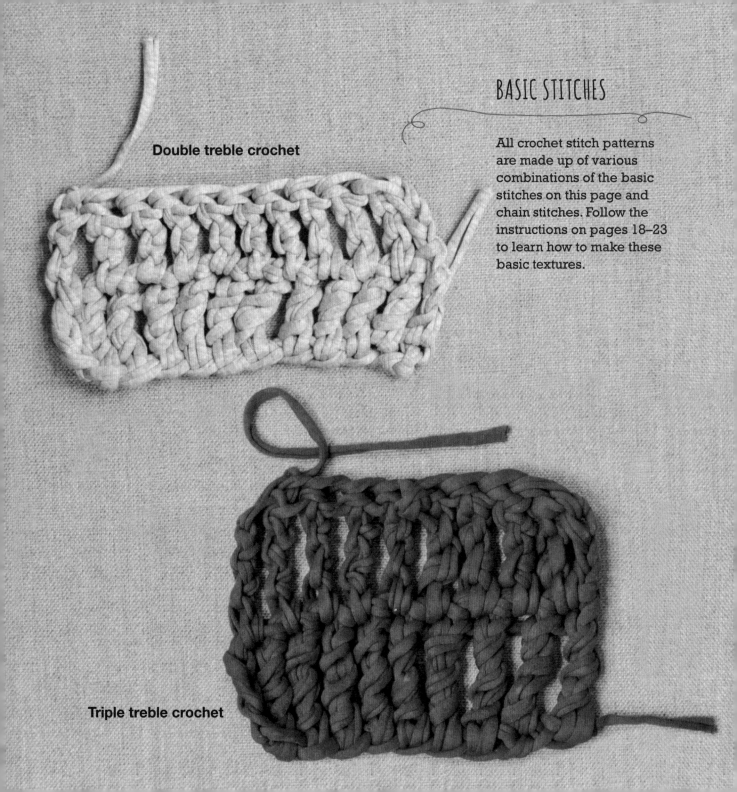

Double treble crochet

All crochet stitch patterns are made up of various combinations of the basic stitches on this page and chain stitches. Follow the instructions on pages 18–23 to learn how to make these basic textures.

Triple treble crochet

WORKING DOUBLE CROCHET

Double crochet is probably the most commonly used crochet stitch, so it is one of the main stitches to master. Each double crochet stitch is made by a simple four-step process.

1 Whether worked into a foundation chain or into stitches in the row below, a double crochet stitch is worked in the same way. For the foundation chain, make as many chains as you want double crochet stitches plus one extra for turning. On the foundation chain, work the first double crochet into the second chain from the hook. *To start the stitch, insert the hook into the chain (or under both loops at the top of the stitch below) and wrap the yarn around the hook as shown above.

2 Draw the yarn through the chain (or stitch below) so there are now two loops on the hook. Then rotate the hook in the usual way to catch the yarn so it is again wrapped around the hook as shown above.

3 Draw the yarn through both the loops on the hook. You have now made one complete double crochet.

4 To continue, insert the hook into the next foundation chain (or stitch below) and repeat from *.

WORKING HALF TREBLE CROCHET

This is another useful crochet stitch, which makes a stitch that is slightly taller than a double crochet but not as tall as a treble crochet. Try it only after you have mastered double crochet.

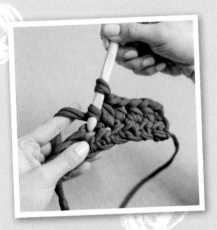

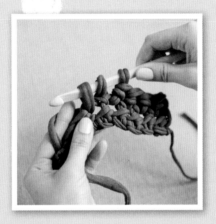

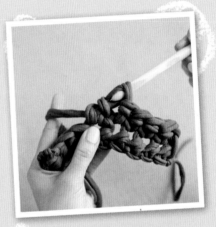

1 To begin, make a foundation chain to the required length. Work the first stitch into the third chain from the hook. To work each stitch, whether into a chain or into a stitch in the row below, start by passing the hook from left to right under the yarn and around it in an anticlockwise movement to catch the yarn in the crook of the hook – called 'yarn round hook' or 'yrh'. Then insert the hook into the chain (or under both loops at the top of the stitch below).

2 Rotate the hook as before to catch the yarn again and draw the yarn through the chain (or the stitch below) so there are now three loops on the hook.

3 Rotate the hook as before to catch the yarn again and draw the yarn through all three loops on the hook. You have now made one complete half treble crochet.

4 To continue, wrap the yarn around the hook and insert the hook into the next foundation chain (or stitch below) and repeat steps 2 and 3.

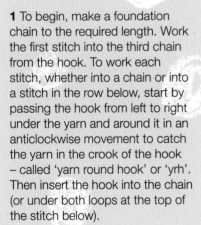

WORKING TREBLE CROCHET

Abbreviation:
tr

Treble crochet is a longer stitch and therefore more open than double crochet, which makes for a softer fabric. It is quite a speedy stitch to complete and is the main stitch used for lacy stitch patterns in combination with chains.

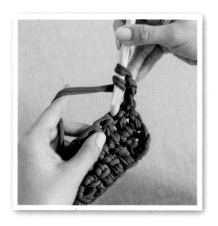

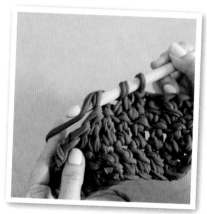

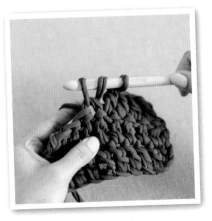

1 To begin, make a foundation chain to the required length, adding three chain to allow for turning. The first stitch is worked into the fourth chain from the hook. Whether working stitches into a foundation chain or into a stitch in the row below, start each stitch by wrapping the yarn around the hook anticlockwise once. Then insert the hook into the chain (or under both loops at the top of the stitch below).

2 Pass the hook from left to right – or anticlockwise – under the yarn to catch the yarn in the crook of the hook again.

3 Draw the yarn through the chain (or the stitch below) so that there are now three loops on the crochet hook.

TIP

Practise making treble crochet stitches onto a foundation chain until you are proficient, then turn to pages 24 and 25 to learn how to work the stitches in rows.

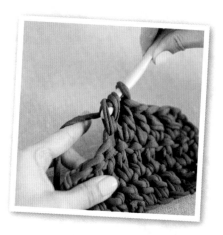

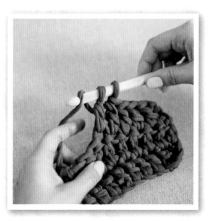

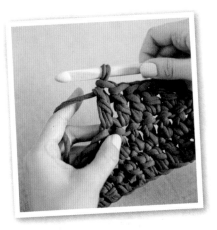

4 Rotate the hook as before to catch the yarn again and draw the yarn through the first two of the loops on the hook.

5 Catch the yarn again and draw it through the remaining two loops on the hook.

6 You have now made one complete treble crochet. To continue, wrap the yarn around the hook, insert the hook into the next foundation chain (or stitch below) and repeat from step 2.

WORKING DOUBLE TREBLE CROCHET

This crochet stitch is three times as tall as double crochet and forms an open fabric with a loose texture. Each double treble is made by a simple five-step process.

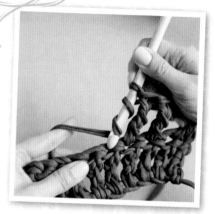

1 On the foundation chain, the first stitch is worked into the fifth chain from the hook. To begin the stitch, whether working into a foundation chain or into a stitch in the row below, first wrap the yarn twice around the hook. Then insert the hook into the foundation chain (or under both loops at the top of the stitch in the row below).

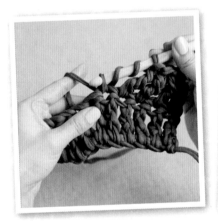

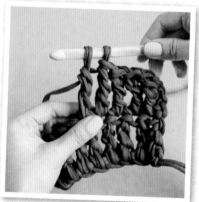

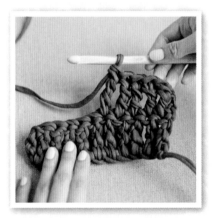

2 Rotate the hook as before to catch the yarn again and draw the yarn through the chain (or the stitch below) so there are now four loops on the hook as shown above. Wrap the yarn around the hook again and draw the yarn through the first two loops on the hook. There are now three loops on the hook.

3 Rotate the hook as before to catch the yarn again and draw the yarn through the first two loops on the hook. There are now two loops on the hook.

4 Rotate the hook as before to catch the yarn again and draw the yarn through the remaining two loops on the hook. You have now made one complete double treble.

5 Continue in the same way, always wrapping the yarn twice around the hook before inserting the hook in the next chain (or stitch).

WORKING TRIPLE TREBLE CROCHET

Abbreviation:
trtr

This crochet stitch is four times as tall as double crochet. Each triple treble is made by a simple six-step process.

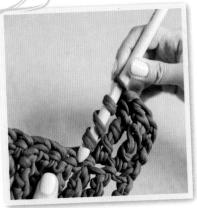

1 On the the foundation chain, the first stitch is worked into the sixth chain from the hook. To begin each stitch, whether working into the foundation chain or the stitches in the row below, first wrap the yarn three times around the hook. Then insert the hook into the foundation chain (or under both loops at the top of the stitch below).

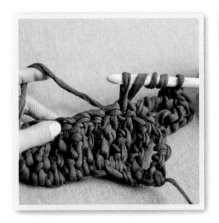

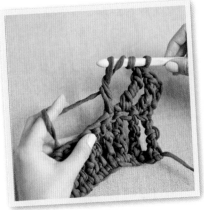

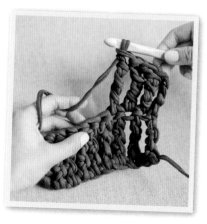

2 Rotate the hook as before to catch the yarn again and draw the yarn through the chain (or the stitch below) so there are now five loops on the hook.

3 Rotate the hook as before to catch the yarn again and draw the yarn through the first two loops on the hook. There are now four loops on the hook as shown above. Rotate the hook as before to catch the yarn again and draw the yarn through the first two loops on the hook. There are now two loops on the hook.

4 Rotate the hook as before to catch the yarn again and draw the yarn through the remaining two loops on the hook. You have now made one complete triple treble.

5 Continue in the same way, always wrapping the yarn three times around the hook before inserting the hook in the next chain (or stitch).

WORKING IN ROWS

When working in rows, always start by making a foundation chain. The first row of your work is worked into this foundation chain. You can insert the hook under either one or two loops of the strands that make up each chain; make sure you consistently work under the same number of loops across the foundation chain to keep it looking neat.

Turning chains

At the beginning of the second and each subsequent row, a number of chain stitches are worked before starting your first basic stitch. This number depends upon the height of the stitch being worked and allows your first stitch to 'stand' alongside this chain – called the turning chain. Sometimes the turning chain is counted as a stitch, so remember to be consistent when including or excluding the turning chain when checking the number of stitches in the row.

TIP Leave a long tail at the slip knot end of the yarn just in case you have miscounted the stitches in your foundation chain, this allows you to add chain stitches if necessary when you reach the end of your first row.

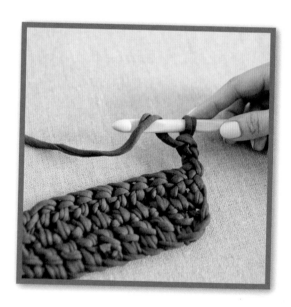

1 In subsequent rows end or begin the following row by making the same number of chains as missed at the beginning of row 1, this is called the turning chain. At the end of the first row turn your work, then make the appropriate number of turning chains to bring the hook to the height of the stitch being used.

Turning chains for basic stitches

Stitch	Add to foundation chain before starting first row	Skip at start of first row (counts as first st)	For turning chain in following rows (counts as first st)
Double	1 ch	1 ch	1 ch
Half treble	1 ch	2 ch	2 ch
Treble	2 ch	3 ch	3 ch
Double treble	3 ch	4 ch	4 ch
Triple treble	4 ch	5 ch	5 ch

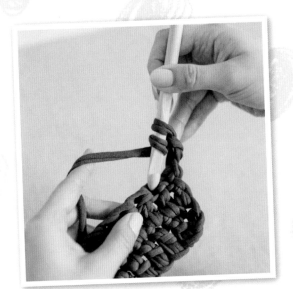

2 If the turning chain is being counted as a stitch, then miss the first stitch of the row below and work the first stitch into the next stitch. Work into each stitch by inserting the hook under the two loops lying on top of the stitch in the previous row. If the turning chain is counted as a stitch, work the last stitch of the row in the top of the turning chain at the end. On the second and subsequent rows be consistent as to whether the turning chain is counted as a stitch or not.

TIP

I would advise beginners to count the number of stitches at the end of each row to make sure they are not accidentally increasing or decreasing the width of the work by adding to or substracting from the number of stitches in the row.

WORKING A BASE RING

Many crochet motifs are created by working in the round. This means you do not need to turn your work at the end of each row, but rather you work with the same side constantly facing you. The majority of the techniques are the same for both working in rows and rounds, however some of the techniques are used in a slightly different way when working in the round. To start your circular motif, you need to create a base (or foundation) ring of chain stitches to work around.

1 Make the required number of chains – your instructions will tell you how many. The more chains that are made at the start, the larger the hole at the centre of the motif will be. Join the chain of stitches into a ring by using a slip stitch: to do this, insert the hook into the first chain.

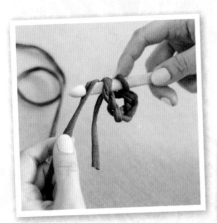

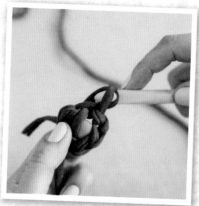

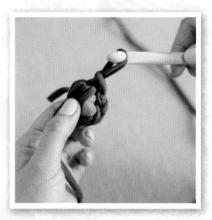

2 Pass the hook from left to right under the yarn and in an anticlockwise movement around it to catch the yarn in the crook of the hook in the usual way.

3 Draw the yarn through the chain and the loop on the hook. This completes the slip stitch.

4 Tighten the base ring by pulling gently on the yarn.

WORKING THE FIRST ROUND

The central ring will be covered over by your first round of stitches, so will not be visible once your work is complete. When all the stitches of the first round have been worked, the last stitch is joined to the top of the first stitch using a simple slip stitch.

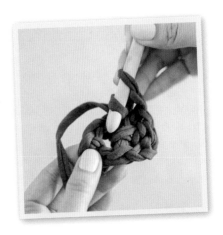

1 Make the base ring, then work the required number of chain stitches to come up to the height of the first stitch. For a treble, as shown here, start the round with three chain stitches (this is the turning chain), then work the following trebles into the ring.

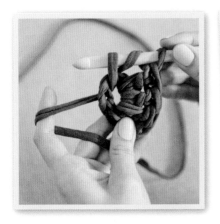

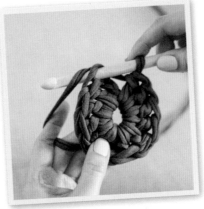

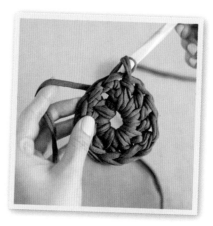

2 Work the stitches as stated in the pattern the number of times required: you may need to bunch up the stitches as you work to make room. Count the stitches at the end of the round, including the turning chain as the first stitch.

3 To join the first round of stitches together, insert the hook from front to back through the top chain of the 3-chain turning chain. Pass the hook from left to right – or anticlockwise – under the yarn to catch the yarn in the crook of the hook.

4 Draw the yarn back through the chain and the loop on the hook. This completes the slip stitch. You will now have one loop on the hook and you are ready to start the next round.

WORKING THE SECOND ROUND

When working in the round, on the second round you work the stitches into the tops of the stitches of the first round. To form a perfect flat circle the number of stitches in the second round will have to be larger than the number of stitches in the first round. Your instructions will always tell you exactly how to do this, so follow them in a methodical way. They are carefully worked out so that the increased number of stitches is spread evenly around the motif. On subsequent rounds more stitches will be added in each round or in every other round to ensure a flat circle. Be sure to count the number of stitches you have at the end of every round, as it is easy to make a mistake and work too few or too many stitches in the round, which would throw out the following rounds.

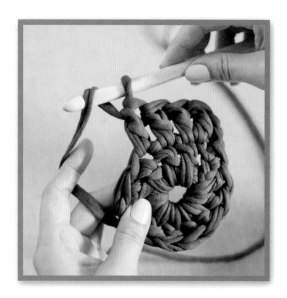

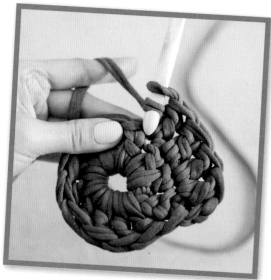

1 Start the second round with the required number of turning chains, in this instance three chains for the treble crochet circle. Increase a stitch in each position instructed. To work an increase, work the first treble into the stitch in the round below then wrap the yarn around the hook.

2 Next, insert the hook into the same stitch that the last stitch was worked into.

Working increases

Increasing in crochet is very simple. It is simply working two stitches into the same loop or space instead of one stitch, as explained left for working in the round. You can increase in almost any part of your work. When working in rows, it is most often near the beginning or end of a row. When working in rounds, it is at evenly spaced points around your work. A slightly different form of increasing is used in the Shells Collar pattern on pages 46–49. Here, a number of stitches are worked into the same chain space on the foundation row to form 'shells'. Then in each subsequent row the number of stitches in each space is increased and the size of the stitch moves from a treble to a double treble to increase the collar's circumference.

Working decreases

Decreasing in crochet usually means skipping over a stitch in the previous row near the beginning and/or at the end of a row so that any gaps are not obvious. There are occasions when decreasing can be done by crocheting two or more stitches together at the top (see the Wavy Scarf pattern on pages 54–57) – these decreases are also known as clusters.

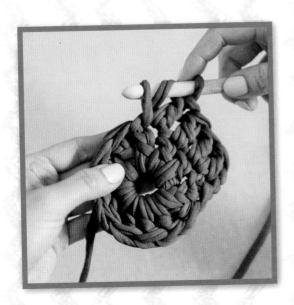

3 Wrap the yarn around the hook and draw the yarn through. There are now three loops on the hook. Complete the treble in the usual way. You have worked an increase by working two treble crochets into the same stitch in the first round. Continue working evenly spaced increases around the circle and at the end join with a slip stitch to the top of the turning chain.

MEASURING TENSION

No matter what you are making, you should try to achieve a correct and even tension in your crochet. This is especially important when making a garment or other item that needs to be a particular size. For an item such as a cushion, however, matching your crochet to the exact tension given in the pattern is less vital, you can always add extra rows or rounds to your work until you reach the size required.

A crochet pattern will specify the number of stitches and rows to a measurement, usually 10cm (4in), when worked over a particular stitch with a certain weight yarn and hook size. Always work a tension swatch before starting a project. If you have more stitches and rows than the pattern states, your tension is too tight so use a larger hook needle. If you have fewer stitches and rows, then your tension is too loose and you should change to a smaller hook size.

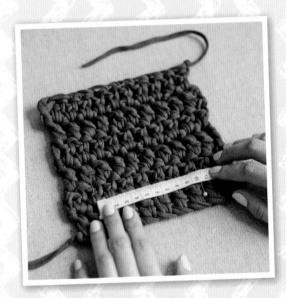

1 Make your tension swatch at least 13cm (5in) square. To measure the number of stitches to 10cm (4in), place a pin at each end and count between the pins.

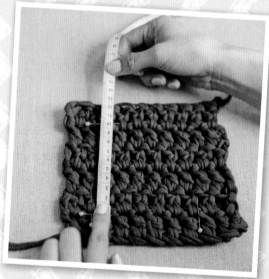

2 Do the same when measuring rows. Be sure to count half stitches and half rows when measuring tension.

FASTENING OFF AND WEAVING IN ENDS

Always take time to finish off your crochet carefully. Here are explanations for what your instructions mean by 'fastening off' and 'sewing (or darning) in ends'.

Fastening off

Once you have finished crocheting any piece, you need to fasten off your work securely. When you have finished the final row or round you will be left with one loop on the hook. Cut the yarn approximately 30cm (12in) from the hook. Wrap the cut yarn around the hook and draw it all the way through the loop on the hook. Pull on the end of the yarn to tighten the knot.

Sewing in ends

Any yarn ends that have not been 'enclosed' by working over them, will need to be darned in by weaving the yarn through some stitches as shown below.

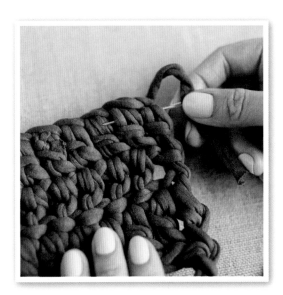

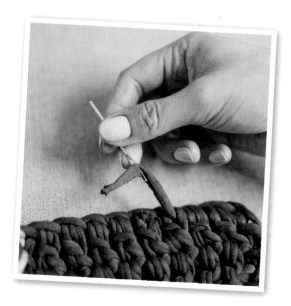

1 Thread the yarn end onto a blunt-ended yarn or tapestry needle. Then weave the needle through at few stitches at the back of the work, being careful not to split the yarn being woven through.

2 Next, clip off the yarn end close to the crochet fabric.

JOINING CROCHET PIECES WITH A SLIP STITCH SEAM

There are many ways to work seams on crochet. You can use sewing techniques like backstitch or overcast stitches, or join the pieces with simple crochet stitches, such as slip stitch or double crochet. The steps here show how to work a slip stitch seam. Before starting the seam, place the pieces to be joined with their right sides together and, if necessary, pin them in position. It is best to use pins with beaded heads as they can be seen more easily and are less likely to get lost in the work.

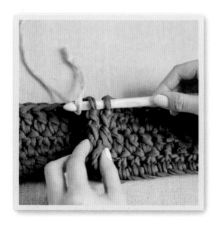 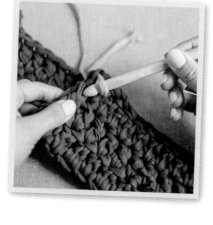 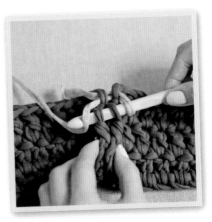

1 Starting at one end of the seam, insert the crochet hook through a stitch on each edge. Then wrap the yarn around the hook and draw a loop through both layers of crochet – this is called 'join with a slip stitch'. (A contrasting yarn is being used here so the seam is visible, but you should use a matching colour when working seams.)

2 Insert the crochet hook into the next pair of corresponding stitches, a short distance from where the first loop was drawn through.

3 Catch the yarn around the hook as before and pull it through both layers of crochet and through the loop on the hook.

Joining work with a yarn needle

Place the pieces to be joined together side by side on a flat surface. Using a blunt-ended yarn or tapestry needle and matching yarn, catch stitch the two pieces together from right to left and back, matching stitch to stitch.

TIP If the yarn is too thick to sew with, try splitting it by pulling the twisted plies apart and using a single strand.
.

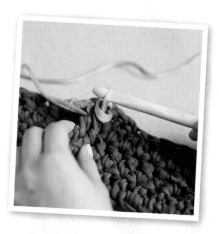

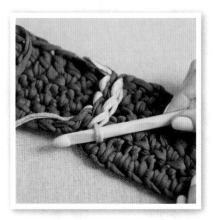

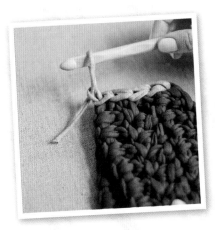

4 This completes the second slip stitch and leaves one loop on the hook. Work the slip stitches firmly to draw the crochet pieces neatly together, but do not work them too tightly.

5 Repeat from step 2 all the way along the seam.

6 When you reach the last stitch, cut off the yarn, wrap the yarn around the hook and draw it all the way through the last loop on the hook. Pull the yarn end to tighten the loop and secure. Sew in the yarn ends as explained on page 31.

ADDING IN A NEW YARN

Whether you are joining in another ball of yarn after one has run out or introducing a new colour, the method is the same for adding in a new yarn. Always introduce a new colour at the beginning of a row or round, unless otherwise specified in the pattern. If you are crocheting stripes, such as for the scarf on pages 54–57, and the gap between the rows is less than 2.5cm (1in), don't cut your yarn when changing colour. Instead, carry it up the side of your work. This saves a huge amount of finishing time.

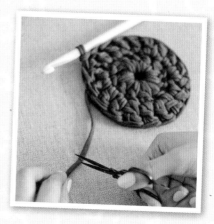

1 If you have finished with the first yarn and it is not to be used again, cut off the yarn leaving an end approximately 10–15cm (4–6in) long. You can either weave this end in later or work over it as explained in these steps.

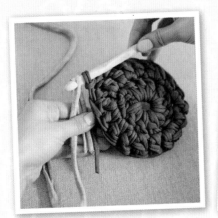

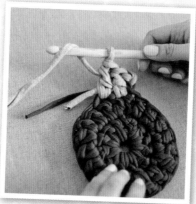

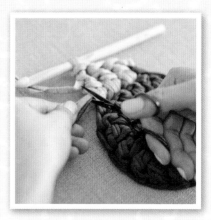

2 Holding the end of the new yarn and the tail of the old yarn together, wrap the new colour around your hook and continue crocheting in pattern.

3 Make your new stitches over the tail ends by placing them along the top of the round or row below. Crochet over the ends for 3cm (1¼in) or so.

4 Cut the tail ends so they cannot be seen. This method saves weaving ends in when your work is complete.

WORKING INTO THE BACK LOOP

Many crochet textures are formed not just by the basic stitches but also by where they are placed and the spaces around them. Although working into the top of a stitch in the row or round below is most common, it is often necessary to work into a chain space, or between stitches or around stitches. A different texture is also created when the hook is inserted through the back loops only of the stitch in the previous row or round as shown below. When creating a textured effect by varying the placement of the stitches, the actual stitch being worked is made in the usual way – it is only the point where the hook is inserted that varies.

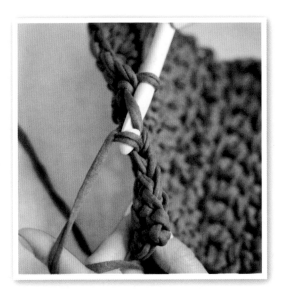

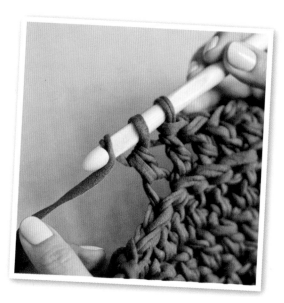

1 These steps show working into the back loop only while working treble crochet. If you look at the top of a basic stitch, you will see a line of loops that look like V-shaped chain stitches. The front side of this V shape is called the 'front loop' and the back side of this V shape is called the 'back loop'. To work a treble into the back loop, wrap the yarn around the hook, then insert the hook under the back loop only of the next stitch as shown.

2 Complete the treble crochet stitch in the usual way. When the front loops of the stitches below are not included, they remain exposed and form a ridge along the row as seen here. This technique – working into only the back loop or only the front loop – can be used with any of the basic stitches to create various ridged textures.

Accessories

- Boot toppers • Pompom hat
- Shells collar • Covered bangles
- Wavy scarf • Wrist warmers
- Tablet case • Jute shopper

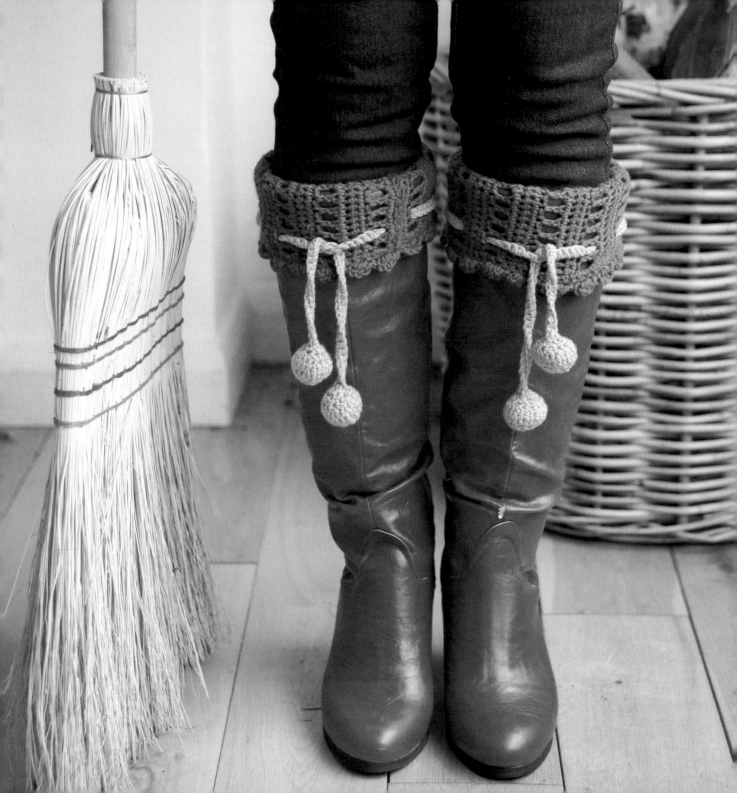

Boot toppers

Whether worn as boot toppers or ankle warmers, these crocheted tubes will hone your crochet skills. You'll learn a simple crochet openwork stitch and how to add a shell edging. Make to any size by stopping when they fit snugly round your calves – or boots.

TO MAKE THE BOOT TOPPERS (MAKE 2)

Foundation chain: Using a 3.5mm (US size E/4) hook and MC, make 48 ch.

Row 1: 1 dc in 2nd ch from hook, 1 dc in each of remaining ch to end, turn. (47 dc)

Row 2: 1 ch (does NOT count as a stitch), 1 dc in each dc to end, turn. (47 dc)

Row 3 (RS): 4 ch (counts as 1 tr and a 1-ch space), miss first 2 dc, 1 tr in next dc, *1 ch, miss 1 dc, 1 tr in next dc; rep from * to end of row, turn.

Row 4: 1 ch (does NOT count as a stitch), 1 dc in first tr, *1 dc in next 1-ch space, 1 dc in next tr; rep from * to end, ending with 1 dc in space at end, 1 dc in 3rd of 4-ch, turn. (44 dc)

Row 5: Rep Row 2.

[Repeat Rows 2–5] 9 times more, then repeat Rows 2–4 once.

(To fit narrower calves, simply work fewer rows.)

Fasten off.

With right sides together, sew foundation-chain edge to top of last row. Turn right side out.

Bottom edging

Work a dc edging around bottom edge of each boot topper as follows:

Round 1 (RS): With RS facing and using a 3.5mm (US size E/4) hook and MC, join yarn with a sl st in edge at seam, 1 ch, 1 dc in same place as sl st, then work dc evenly along edge, working 1 dc in each dc row end and 2 dc in each tr row end, join with a sl st to top of first dc at beginning of round. (55 dc) Continue in rounds with RS always facing.

Round 2: 1 ch, 1 dc in same place as last sl st, 1 dc in each of next 3 dc, miss next dc, *1 dc in each of next 4 dc, miss next dc; rep from * to end, join with a sl st to top of first dc at beginning of round. (44 dc)

Round 3: 1 ch, 1 dc in same place as last sl st, 1 dc in each dc to end, join with a sl st to top of first dc at beginning of round.
Fasten off.

SUPPLIES

CROCHET HOOKS:
2.5mm and 3.5mm (US sizes C/2 and E/4) crochet hooks

YARNS:
Debbie Bliss Yarns *Rialto DK*, or a similar lightweight wool yarn, in two colours:
 MC 3 x 50g (1¾ oz) balls in teal
 CC 1 x 50g (1¾ oz) ball in gold

TENSION:
18 sts and 16 rows to 10cm (4in) measured over stitch pattern using a 3.5mm (US size E/4) hook.

SIZE:
28cm (11in) around calf (unstretched) x 28cm (11cm) long

ABBREVIATIONS:
See inside back-cover flap.

PATTERN NOTE:
The boot toppers are crocheted to wrap around the leg – the foundation-chain edge is joined to the final row and the top and bottom edgings are added along the side edges of the crochet.

Top edging

Work a dc edging around top edge of each boot topper as follows:

Round 1 (RS): With RS facing and using a 3.5mm (US size E/4) hook and MC, join yarn with a sl st in edge at seam, 1 ch, 1 dc in same place as sl st, then work dc evenly along edge, working 1 dc in each dc row end and 2 dc in each tr row end, join with a sl st to top of first dc at beginning of round. (55 dc)
Continue in rounds with RS always facing.

Round 2: 1 ch, 1 dc in same place as last sl st, 1 dc in each dc to last dc, miss last dc, join with a sl st to top of first dc at beginning of round. (54 dc)

Row 3: 3 tr in next dc, *1 sl st in each of next 2 dc, 3 tr in next dc; rep from * to last dc, 1 sl st in last dc. Fasten off.
Sew in any loose yarn ends.

TO MAKE THE TIES (MAKE 2)

Foundation chain: Using a 2.5mm (US size C/2) hook and CC, make 121 ch loosely.

Row 1: 1 dc in 2nd ch from hook, 1 dc in each of remaining ch to end. (120 dc)
Fasten off.
Sew in any loose yarn ends.

TO MAKE THE BOBBLES (MAKE 4)

Base ring: Wind yarn around a finger twice to form a ring of yarn, then remove and, using a 2.5mm (US size C/2) hook, work in rounds as follows:

Round 1 (RS): 1 sl st in ring, 1 ch, 6 dc in ring, then pull loose yarn end to tighten circle.
Marking beginning of each round to keep track of where to start next round, continue in rounds in a spiral with RS always facing.

Round 2: 2 dc in each dc to end of round. (12 dc)

Round 3: 1 dc in each dc to end of round. (12 dc)

Round 4: 2 dc in each dc to end of round. (24 dc)

Round 5: 1 dc in each dc to end of round. (24 dc)

Round 6: [Miss 1 dc, 1 dc in next dc] to end of round. (12 dc)
Stuff bobble firmly with short lengths of CC (see below right).

Round 7: [Miss 1 dc, 1 dc in next dc] to end of round. (6 dc)
Insert more stuffing if necessary.

Round 8: [Miss 1 dc, 1 dc in next dc] to end of round. (3 dc)
Fasten off, leaving a long yarn end.

TO FINISH

Thread Bobble yarn end onto a blunt-ended yarn needle and weave around opening to close hole at top of bobble. Sew one Bobble to one end of each Tie.
Thread each Tie onto a boot topper, lacing the tie through the second row of chain spaces below the top edging. Once the Ties are threaded in place, sew a Bobble to the opposite end of each tie.

KEY

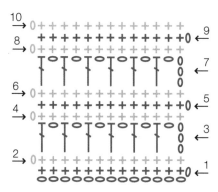

= chain stitch

= double crochet

= treble crochet

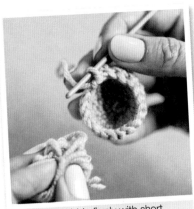

Stuff the bobble firmly with short lengths of matching yarn.

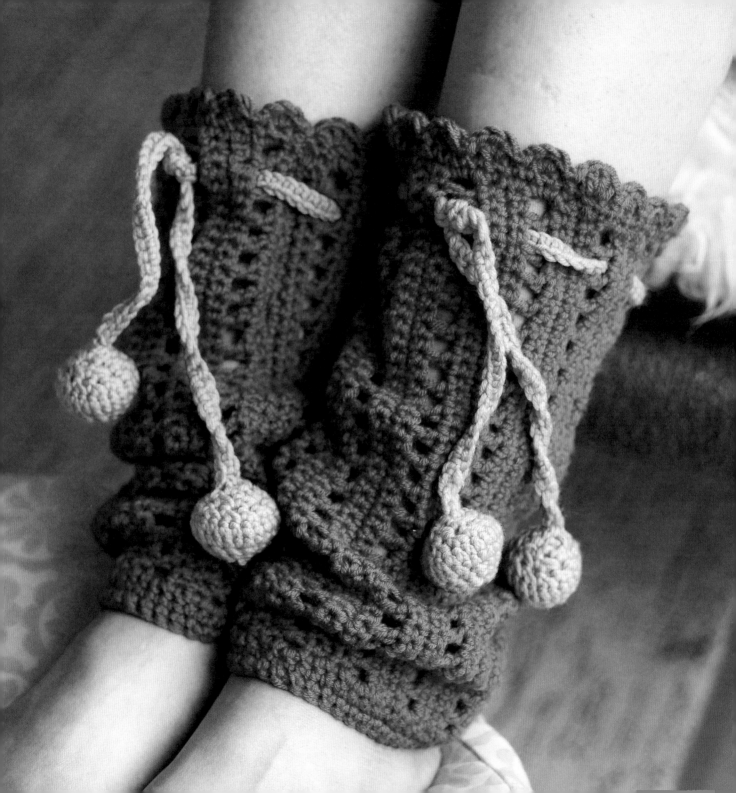

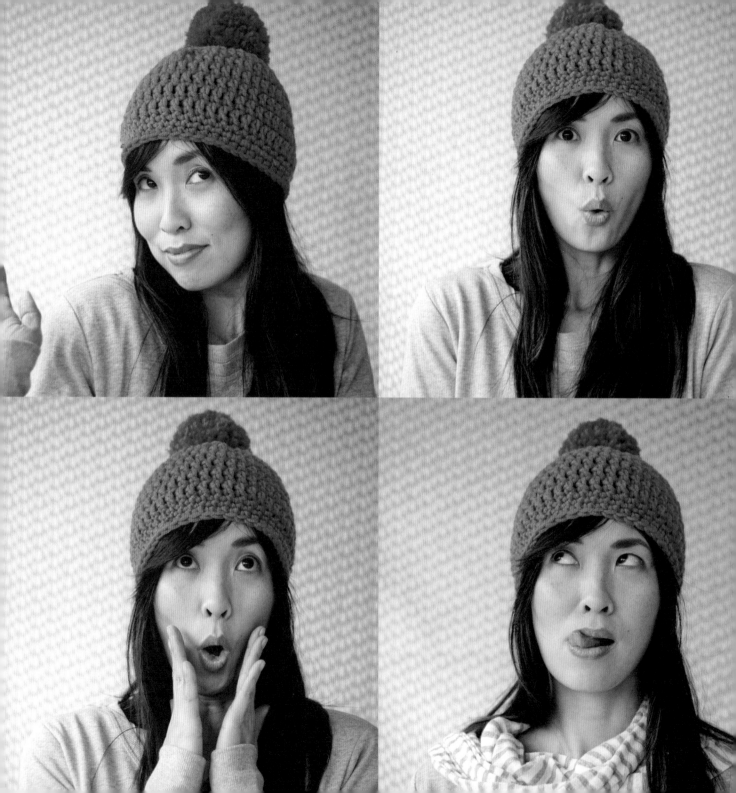

Pompom hat

Crocheting tall treble stitches with chunky wool yarn is so satisfying – start this hat today and wear it tomorrow! Begun at the centre of the top and worked in rounds, it has no seams to slow down the process. The giant pompom adds panache.

TO MAKE THE HAT

Base ring: Using a 6mm (US size J/10) hook and MC, make 5 ch and join with a sl st in first ch to form a ring.

Round 1 (RS): 3 ch (counts as 1 tr), 11 tr in ring, join with a sl st in top of 3-ch at beginning of round. (12 sts)
Continue in rounds with RS always facing.

Round 2: 3 ch (counts as 1 tr), 1 tr in same place as last sl st, 2 tr in each tr to end of round, join with a sl st in top of 3-ch at beginning of round. (24 sts)

Round 3: 3 ch (counts as 1 tr), 1 tr in same place as last sl st, *1 tr in next tr, 2 tr in next tr; rep from * to last tr, 1 tr in last tr, join with a sl st in top of 3-ch at beginning of round. (36 sts)

Round 4: 3 ch (counts as 1 tr), 1 tr in same place as last sl st, *1 tr in each next 2 tr, 2 tr in next tr; rep from * to last 2 tr, 1 tr in each of next 2 tr, join with a sl st in top of 3-ch at beginning of round. (48 sts)

Round 5: 3 ch (counts as 1 tr), 1 tr in each tr to end of round, join with a sl st in top of 3-ch at beginning of round. (48 sts)

Rounds 6–9: [Rep Round 5] 4 times.
Change to a 5mm (US size H/8) hook.

Round 10: 1 ch (does NOT count as a stitch), 1 dc in same place as last sl st, 1 dc in each tr to end of round, join with sl st in top of first dc at beginning of round.

Round 11: 1 ch (does NOT count as a stitch), 1 dc in same place as last sl st, 1 dc in each dc to end of round, change to CC and join with sl st to top of first dc at beginning of round.
Cut off MC and continue with CC.

Round 12: 1 ch (does NOT count as a stitch), 1 dc in same place as last sl st, 1 dc in each dc to end of round, join with sl st in top of first dc at beginning of round.
Fasten off.

TO FINISH

Sew in any loose yarn ends. Then add the pompom (see next page).

SUPPLIES

CROCHET HOOKS:
5mm and 6mm (US sizes H/8 and J/10) crochet hooks

YARNS:
Mondial Yarns *Cross Chunky,* or a similar chunky-weight wool yarn, in two colours:
 MC 1 x 100g (3½oz) ball in teal
 CC 1 x 100g (3½oz) ball in raspberry

TENSION:
9 sts and 5½ rows to 10cm (4in) measured over treble crochet using a 6mm (US size J/10) hook.

SIZE:
To fit a medium-size woman's head

ABBREVIATIONS:
See inside back-cover flap.

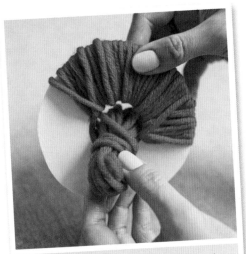

1 Wrap the yarn around the two cardboard rings until they are densely covered.

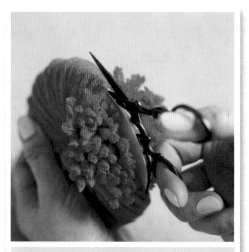

2 Cut the yarn by inserting the tip of the scissors between the rings.

TO MAKE THE POMPOM

Cut a cardboard ring about 14cm (5½in) in diameter and with a hole in the centre about 4cm (1½in) in diameter; then make a second identical cardboard ring. Place the two rings together and thread the yarn round and round the rings (**1**) – the more yarn you use, the thicker the pompom will be. Holding the wrapped rings securely, cut the yarn around the edge of the rings, inserting the scissor tip between the rings as you cut (**2**). Tie a long length of yarn securely around the centre of the strands between the rings (**3**), pull tightly and knot. Gently remove the rings and fluff up the pompom. Trim into shape if necessary, but leave the long tying strands. Using the tying strands, sew the pompom to the centre of the top of the hat.

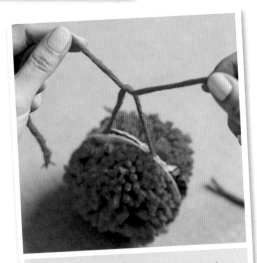

3 Tie the yarn strands together between the rings before removing the cardboard.

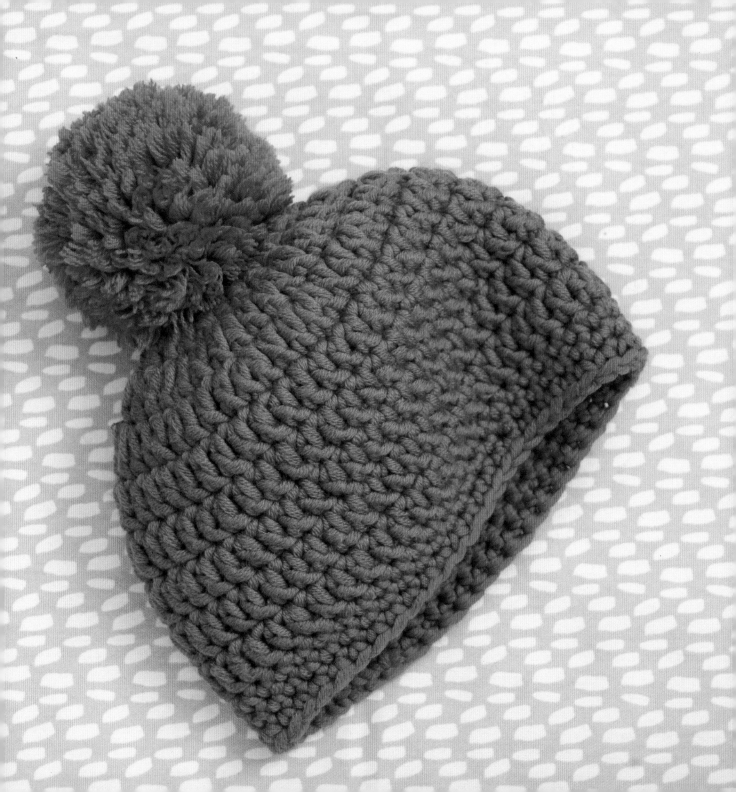

Shells collar

Practise your newfound crochet skills with this lacy cotton collar made in repeating rows of shell stitches. It will provide a dainty detail for a plain slipover or cardigan – tied on at the back or front, whichever takes your fancy.

SUPPLIES

CROCHET HOOK:
2mm (US size B/1) crochet hook

YARN:
Yeoman Yarns *Cannele 4-ply,* or a similar super-fine-weight mercerised cotton yarn, in one colour:
40g (1⅜oz) – or 140m (153yd) – in linen

EXTRAS:
Small amount of safety toy stuffing to fill bobbles

TENSION:
Collar measures 8cm (3¼in) wide using a 2mm (US size B/1) hook.

SIZE:
Inside neck edge on finished collar measures 34cm (13½in), excluding ties

ABBREVIATIONS:
See inside back-cover flap.

TO MAKE THE COLLAR

Foundation chain: Using a 2mm (US size B/1) hook, make 89 ch.

Row 1 (WS): 1 tr in 4th ch from hook (3 missed ch count as first tr), miss next 4 ch, [2 tr, 1 ch, 2 tr] in next ch, *miss next 4 ch, [2 tr, 1 ch, 2 tr] in next ch; rep from * to last 5 ch, miss next 4 ch, 2 tr in last ch, turn. (Sixteen '2 tr, 1 ch, 2 tr' shell groups, plus a half shell at each end)

Row 2 (RS): 3 ch (counts as first tr), 2 tr in first tr, *[3 tr, 1 ch, 3 tr] in next 1-ch space; rep from * 15 times more, ending with 3 tr in top of 3-ch at end of row, turn. (Sixteen '3 tr, 1 ch, 3 tr' shell groups, plus a half shell at each end)

Row 3: 4 ch, 2 dtr in first tr, *[3 dtr, 1 ch, 3 dtr] in next 1-ch space; rep from * 15 times more, ending with 3 dtr in top of 3-ch at end of row, turn. (Sixteen '3 dtr, 1 ch, 3 dtr' shell groups, plus a half shell at each end)

Row 4: 4 ch, 3 dtr in first tr, *[4 dtr, 1 ch, 4 dtr] in next 1-ch space; rep from * 15 times more, ending with 4 dtr in top of 4-ch at end of row, turn. (Sixteen '4 dtr, 1 ch, 4 dtr' shell groups, plus a half shell at each end)

Shape Peter Pan collar edge
The next row has no turning chain, which starts to shape the curved edge of the collar.

Row 5: *[5 dtr, 1 ch, 5 dtr] in next 1-ch space; rep from * 15 times more, ending with 1 sl st in top of 4-ch at end of row, turn. (Sixteen '5 dtr, 1 ch, 5 dtr' shell groups)

Row 6: 1 sl st in each of first 5 dtr, 1 sl st in first 1-ch space, [6 dtr, 1 ch, 6 dtr] in next 1-ch space; rep from * 13 times more, ending with 1 sl st in last 1-ch space. (Fourteen '5 dtr, 1 ch, 5 dtr' shell groups)
Fasten off.

Sew in any loose yarn ends.

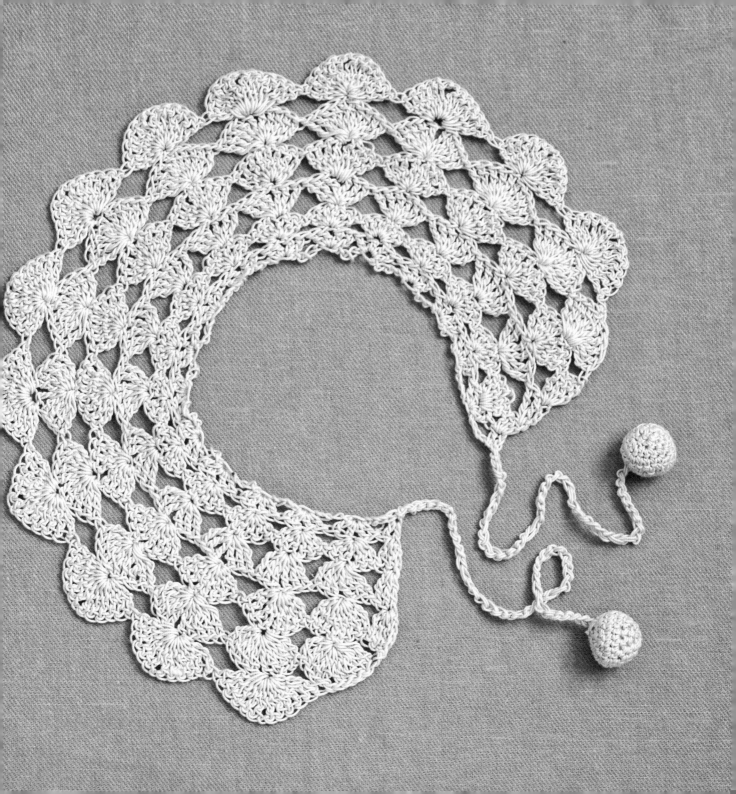

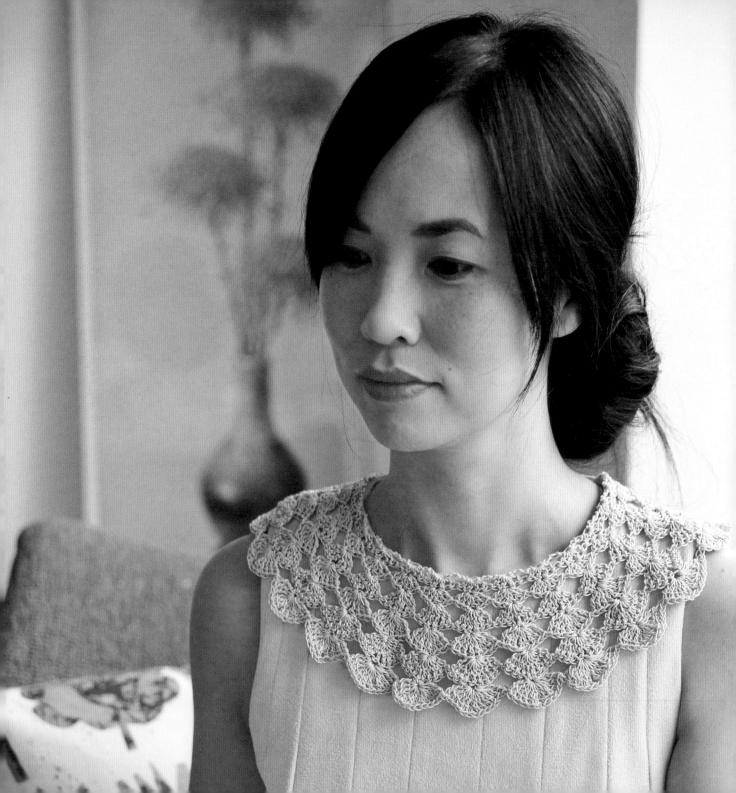

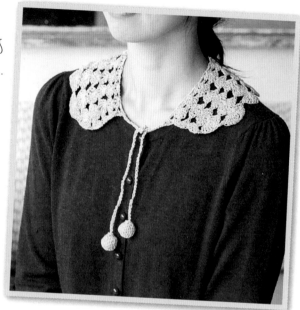

WEAR THE COLLAR WITH THE TIES
AT THE FRONT OR THE BACK.

TO MAKE THE BOBBLES (MAKE 2)

Base ring: Wind yarn around a finger twice to form a ring of yarn, then remove and, using a 2mm (US size B/1) hook, work in rounds as follows:

Round 1 (RS): 1 sl st in ring, 1 ch, 6 dc in ring, then pull loose yarn end to tighten circle.

Marking beginning of each round to keep track of where to start next round, continue in rounds in a spiral with RS always facing.

Round 2: 2 dc in each dc to end of round. (12 dc)

Round 3: 1 dc in each dc to end of round. (12 dc)

Round 4: 2 dc in each dc to end of round. (24 dc)

Round 5: 1 dc in each dc to end of round. (24 dc)

Round 6: [Miss 1 dc, 1 dc in next dc] to end of round. (12 dc)

Round 7: [Miss 1 dc, 1 dc in next dc] to end of round. (6 dc)

Fill bobble firmly with toy stuffing. Fasten off, leaving a long yarn end. Thread yarn end onto a blunt-ended yarn needle, weave it through 6 sts of last round, pull tightly to gather and secure.

TO MAKE THE TIES (MAKE 2)

Cut a 2.8m (3yd) length of yarn and fold it in half. Pull the loop at the folded end through one inside neck edge corner of the collar, then, using a 2mm (US size B/1) hook, insert hook in loop and make 40 ch loosely with the doubled strand. Fasten off.

Make a second Tie on the other inside neck edge corner of the collar in the same way.

TO FINISH

Sew one Bobble to the end of each Tie.

Sew in any loose yarn ends.

Covered bangles

Not much could be easier or quicker than covering bangles with whatever mercerised cotton colours suit your wardrobe. And you can never have too many. The only crochet skill you need is how to work the very basic double crochet stitches.

CROCHET HOOK:
2.5mm (US size C/2) crochet hook

YARNS:
Yeoman Yarns *Cannele 4-ply*, or a similar super-fine-weight mercerised cotton yarn, in 7 colours:
 A Small amount in linen
 B Small amount in gold
 C Small amount in pale blue
 D Small amount in brown
 E Small amount in tangerine
 F Small amount in raspberry
 G Small amount in pale grey

EXTRAS:
7 bangles to fit wrist
Note: Make sure the bangles you choose slip easily over your hand as the crochet will make the inner dimension of the circle slightly smaller.

TENSION:
Working to an exact tension is not important for this project, as the crochet is worked to fit each bangle.

SIZE:
The crochet can be worked onto any size bangle (see Note with Extras)

ABBREVIATIONS:
See inside back-cover flap.

YARN NOTE:
For a bangle that measures approximately 4cm (1½in) around the bangle ring and has an inner diameter of approximately 6.5cm (2½in), you will need approximately 8g (¼oz) of yarn – or 28m (30½yd).

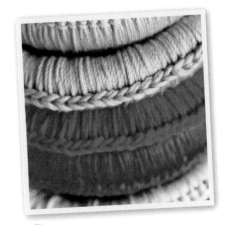

THE TOPS OF THE DOUBLE CROCHET STITCHES FORM LITTLE RIDGES OF CHAIN STITCHES.

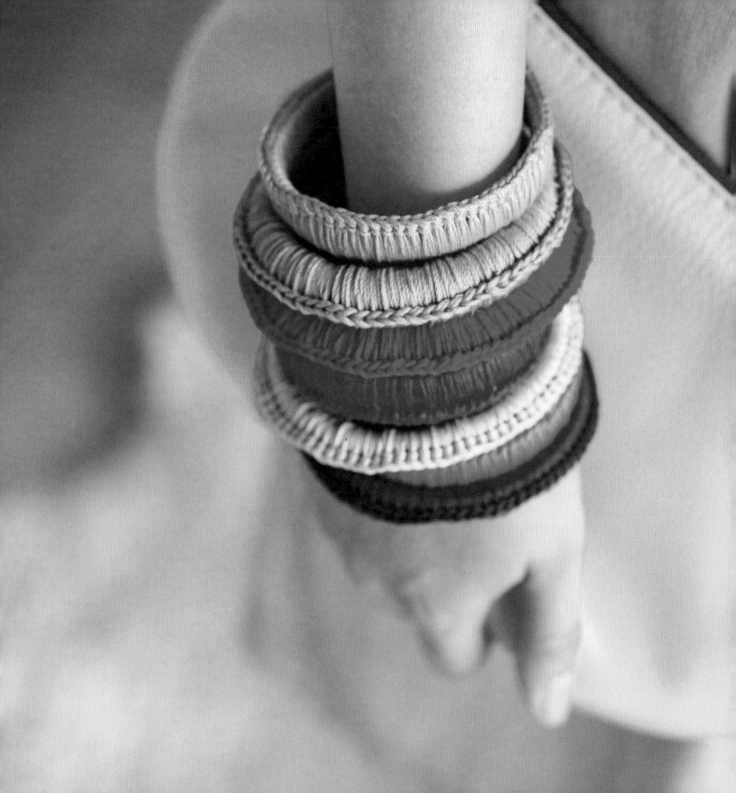

1 For each dc, insert hook through bangle and draw a loop through it.

2 Wrap the yarn around the hook again and complete the dc.

TO COVER THE BANGLES

Using a 2.5mm (US size C/2) hook and two strands of A held together, hold bangle as you would a ring of crochet chain, then insert hook from front to back through bangle, wrap yarn around hook (yrh) and pull a loop through bangle to front, work 1 chain, then work 1 dc into the bangle as you would into a crochet ring (see page 52). Continue working dc around bangle in this way until it is covered – a bangle with an inner diameter of 6.5cm (2½in) and that measures 4cm (1½in) around its ring requires about 90 dc.

Cut off yarn, leaving long loose yarn ends, and pull yarn ends through top of last dc.

Cover remaining six bangles with yarns B, C, D, E, F and G in the same way.

TO FINISH

Thread the yarn ends onto a blunt-ended yarn needle and join the last dc on the bangle to first dc. Then weave the yarn ends through the dc loops to secure and trim.

3 Continue working dc in the same way to completely cover the bangle.

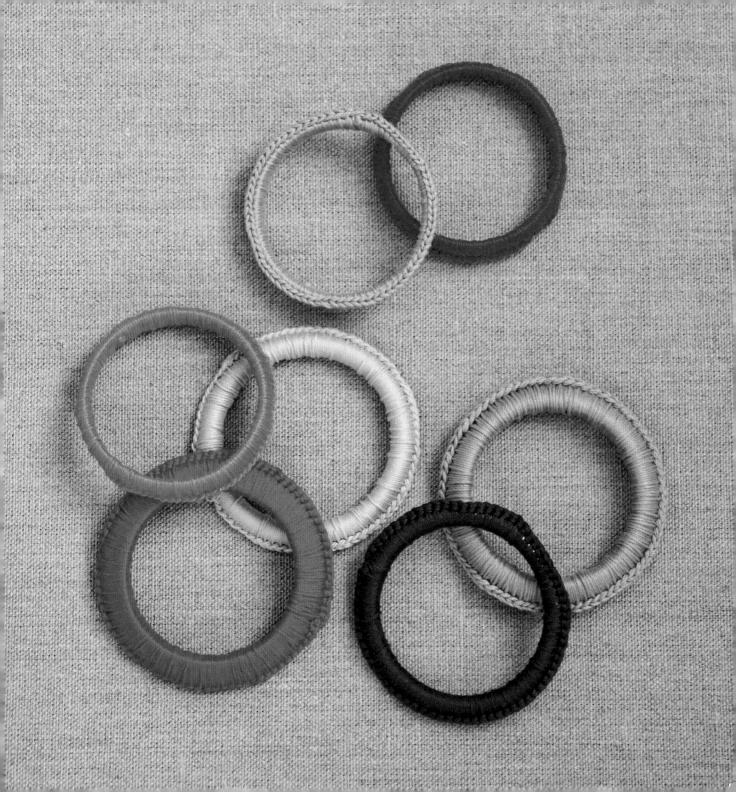

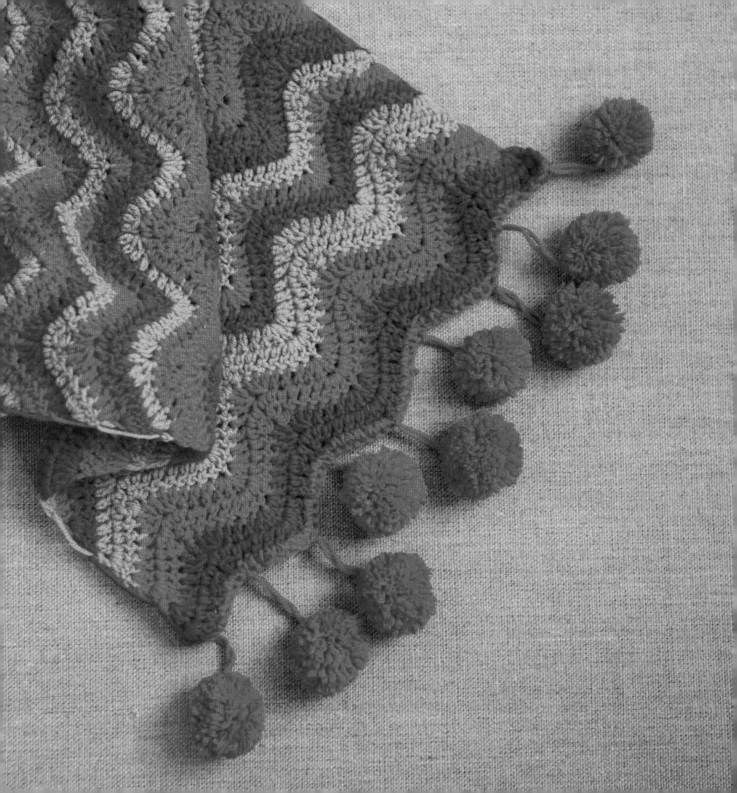

Wavy scarf

Worked in a vintage crochet pattern, this scarf with dangling mini pompoms is easier to crochet than it looks. Once you get going you won't have to read the pattern or the stitch diagram any more – except to keep track of those jazzy coloured stripes.

TO MAKE THE SCARF

Foundation chain: Using a 3mm (US size D/3) hook and A, make 59 ch.

Row 1: 2 tr in 4th ch from hook (3 missed ch count as 1 tr), *1 tr in each of next 3 ch, [tr3tog over next 3 ch] twice, 1 tr in each next 3 ch, [3 tr in next ch] twice; rep from * to last 13 ch, 1 tr in each of next 3 ch, [tr3tog over next 3 ch] twice, 1 tr in each next 3 ch, 3 tr in last ch, turn.

Row 2: 3 ch (counts as 1 tr), 2 tr in first tr, *1 tr in each next 3 tr, [tr3tog over next 3 tr] twice, 1 tr in each next 3 tr**, [3 tr in next tr] twice; rep from * to last 13 sts, then rep from * to ** once more, ending with 3 tr in top of 3-ch at end of row, turn. Working in stripes, repeat Row 2 every row and do not cut off yarns, but carry them up the sides of the work, changing yarn colours as follows:

Rows 3 and 4: Using B, [rep Row 2] twice.

Rows 5 and 6: Using C, [rep Row 2] twice.

Row 7: Using A, rep Row 2.

Row 8: Using B, rep Row 2.

Row 9: Using C, rep Row 2.

Rows 10 and 11: Using A, [rep Row 2] twice.

Rows 12 and 13: Using B, [rep Row 2] twice.

Rows 14 and 15: Using C, [rep Row 2] twice.

Rows 16–19: Rep Rows 10–13.

Row 20: Using C, rep Row 2.

Row 21: Using A, rep Row 2.

Row 22: Using B, rep Row 2.

Rows 23–31: [Rep Rows 20–22] 3 times.

Rows 32–38: Using C, [rep row 2] 7 times.

Rows 39–44: [Rep rows 7–9] twice.

Rows 45–50: Using C, [rep Row 2] 6 times.

Row 51: Using B, rep Row 2.

Row 52: Using A, rep Row 2.

Row 53: Using C, rep Row 2.

Rows 54–56: Rep Rows 51–53.

Rows 57–62: Using C, [rep Row 2] 6 times.

Rows 63–74: [Rep Rows 51–53] 4 times.

Rows 75 and 76: Using B, [rep Row 2] twice.

Rows 77 and 78: Using A, [rep Row 2] twice.

SUPPLIES

CROCHET HOOK:
3mm (US size D/3) crochet hook

YARNS:
Debbie Bliss Yarns *Rialto 4-ply*, or a similar super-fine-weight wool yarn, in 3 colours:
 A 1 x 50g (1¾oz) ball in red
 B 1 x 50g (1¾oz) ball in fuchsia
 C 2 x 50g (1¾oz) balls in pale tangerine

TENSION:
24 sts and 9 rows to 10cm (4in) measured over chevron stitch pattern using a 3mm (US size D/3) hook.

SIZE:
26cm (10¼in) wide by 114cm (44¾in) long, excluding pompoms

ABBREVIATIONS:
tr3tog (treble crochet 3 stitches together): [Yrh and insert hook in next st, yrh and draw a loop through, yrh and draw through first 2 loops on hook] 3 times, yrh and draw through all 4 loops on hook.
See also inside back-cover flap.

1 Start each tr3tog with 3 partial tr, working each only up to the last yrh.

2 Complete the tr3tog by drawing a loop through all 4 loops on the hook.

KEY

◯ = chain stitch

T = treble crochet

Ⱶ = tr3tog

Rows 79 and 80: Using C, [rep Row 2] twice.
Rows 81–84: Rep Rows 75–78.
Row 85: Using C, rep Row 2.
Row 86: Using B, rep Row 2.
Row 87: Using A, rep Row 2.
Rows 88 and 89: Using C, [rep Row 2] twice.
Rows 90 and 91: Using B, [rep Row 2] twice.
Rows 92 and 93: Using A, [rep Row 2] twice.
Cut off only A and C. Do not fasten off yet, but continue with B for last edging row.
Edging
Row 94: Using B, 1 ch, 1 dc in each tr to end.
Fasten off.

Using a 3mm (US size D/3) hook and B, join yarn with a sl st in underside of first ch on foundation-chain edge, 1 ch, 1 dc in same place as sl st, 1 dc in each ch to end.
Fasten off.

TO FINISH
Sew in any loose yarn ends.
Mini pompoms
Using B, make 18 mini pompoms 3–3.5cm (1¼–1⅜in) in diameter following the step-by-step instructions on pages 110 and 111. Using the two yarn ends of the tying strand, tie a pompom to each peak and arch at either end of the scarf, joining at random lengths.

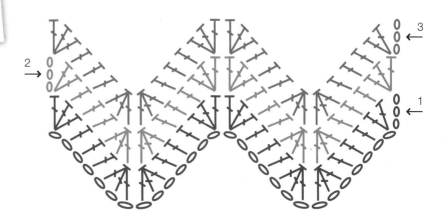

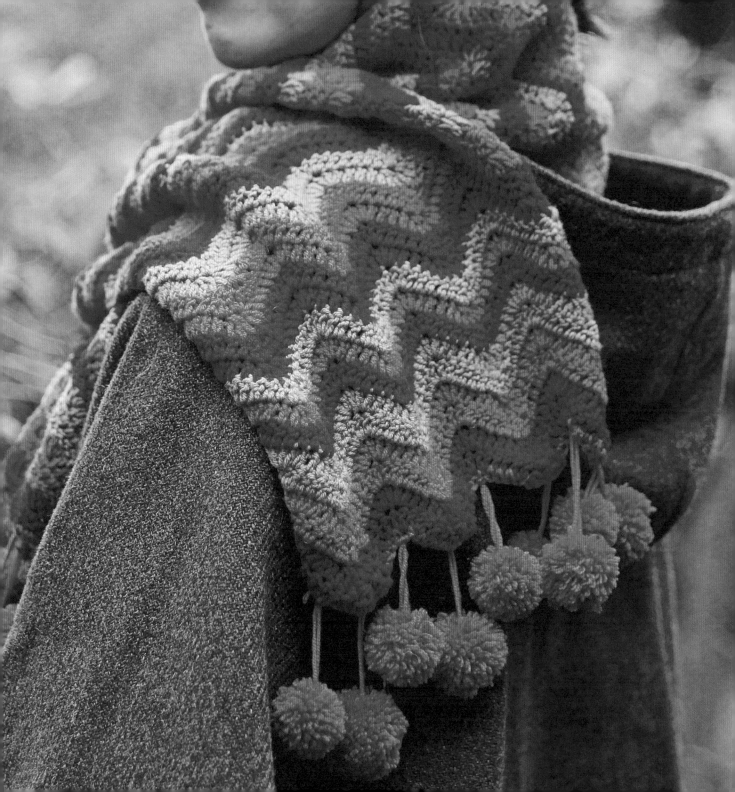

Wrist warmers

Even a novice crocheter can whip up these cosy woollen wrist warmers as they are made from simple strips of the most basic crochet stitch – double crochet. Choose your all-time favourite shades for these two-tone fingerless mittens.

CROCHET HOOKS:
4.5mm and 5mm (US sizes 7 and H/8) crochet hooks

YARNS:
Rowan Yarns *Creative Focus Worsted*, or a similar medium-weight wool yarn, in two colours:

Short version
MC 1 x 50g (1¾oz) ball in rose pink (02755 Deep Rose) or light grey (00401 Nickel)
CC 1 x 50g (1¾oz) ball in light grey (00401 Nickel) or gold (01837 Saffron)

Long version
MC 2 x 50g (1¾oz) balls in charcoal grey (00402 Charcoal Heather)
CC 1 x 50g (1¾oz) ball in olive green (01265 New Fern)

TENSION:
14 sts and 18 rows to 10cm (4in) measured over double crochet using a 4.5mm (US size 7) hook.

SIZE:
To fit a woman's medium hand size
Short version: 17cm (6¾in) in circumference (unstretched) x 15.5cm (6in) long
Long version: 17cm (6¾in) in circumference (unstretched) x 21cm (8¼in) long

ABBREVIATIONS:
See inside back-cover flap.

PATTERN NOTE:
The crochet rows run vertically up and down the wrist warmers rather than horizontally.

TO MAKE THE WRIST WARMERS (MAKE 2)
Foundation chain: Using a 5mm (US size H/8) hook and MC, make 21 ch for short version or 30 ch for long version.
Change to a 4.5mm (US size 7) hook.
Row 1: 1 dc in 2nd ch from hook, 1 dc in each of remaining ch to end, turn. (20 dc on short version or 29 dc on long version)
Row 2: 1 ch (does NOT count as a stitch), 1 dc in each dc to end, turn. (20 dc on short version or 29 dc on long version)
[Repeat Row 2] 28 times more.
Fasten off.

TO FINISH THE SHORT VERSION
With right sides together, sew foundation-chain edge to top of last row on each wrist warmer, leaving a 5.5cm (2⅛in) opening for the thumb – centre the thumb hole in the seam. Turn wrist warmers right side out.

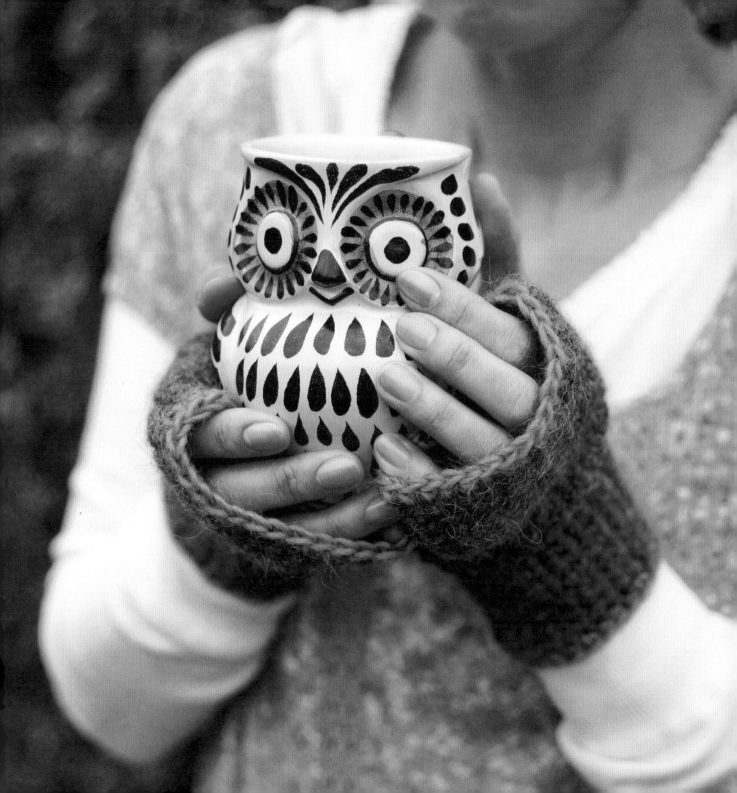

Top edging

Work a dc edging around top edge of each wrist warmer as follows:

Round 1 (RS): With RS facing and using a 4.5mm (US size 7) hook and CC, join yarn with a sl st in edge at seam, 1 ch, 1 dc in same place as sl st, then work dc evenly along edge, working 1 dc in each dc row end, join with a sl st in top of first dc at beginning of round.

Continue in rounds with RS facing.

Round 2: 1 ch, 1 dc in same place as last sl st, 1 dc in each dc to end, join with a sl st in top of first dc at beginning of round.

Fasten off.

Cuff edging

With right side facing and using a 5mm (US size H/8) hook and CC, work 1 round of dc around cuff edge as for Round 1 of Top Edging.

Fasten off.

Thumb-hole edging

Work a dc edging around thumb hole of each wrist warmer as follows:

Round 1 (RS): With RS facing and using a 4.5mm (US size 7) hook and CC, join yarn with a sl st in thumb opening edge at seam, 1 ch, 1 dc in same place as sl st, then work dc evenly along one side edge of thumb hole, working 1 dc in each dc row end, then work 1 dc in seam and work dc evenly along other side edge, join with a sl st in top of first dc at beginning of round.

Fasten off.

Sew in any loose yarn ends.

TO FINISH THE LONG VERSION

With right sides together, sew the foundation-chain edge to the top of the last row on each wrist warmer, leaving a 5.5cm (2⅛in) opening for the thumb – position the thumb hole 6cm (2¼in) from the top edge. Turn wrist warmers right side out.

Edgings

Work a dc edging around top edge as for Round 1 on short version. Work cuff edging and thumb-hole edging as for short version. Sew in any loose yarn ends.

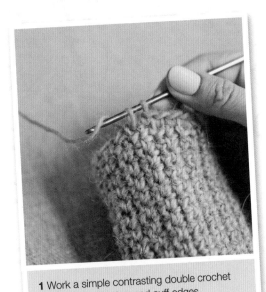

1 Work a simple contrasting double crochet edging along the top and cuff edges.

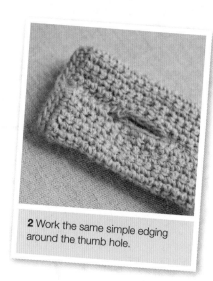

2 Work the same simple edging around the thumb hole.

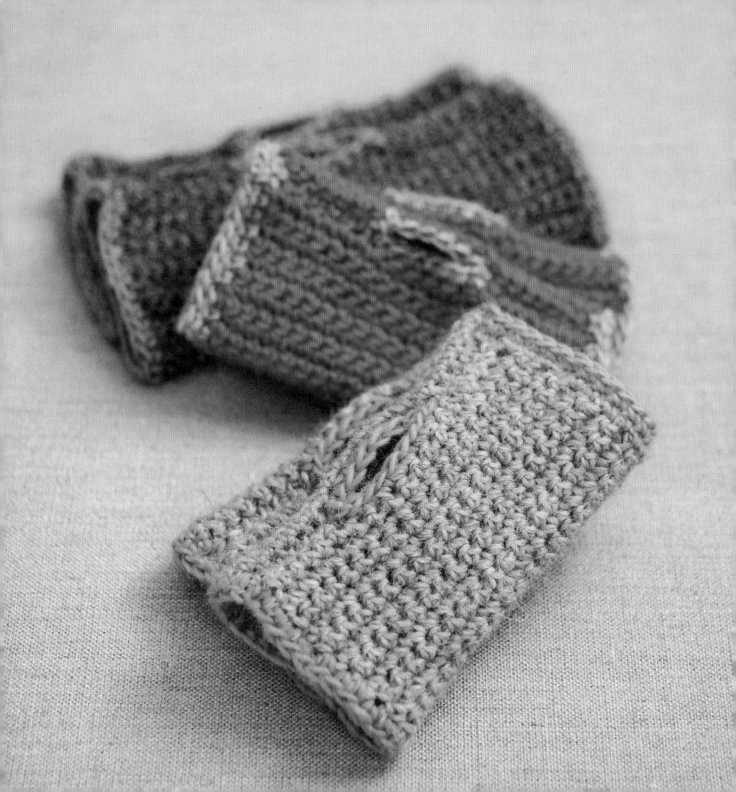

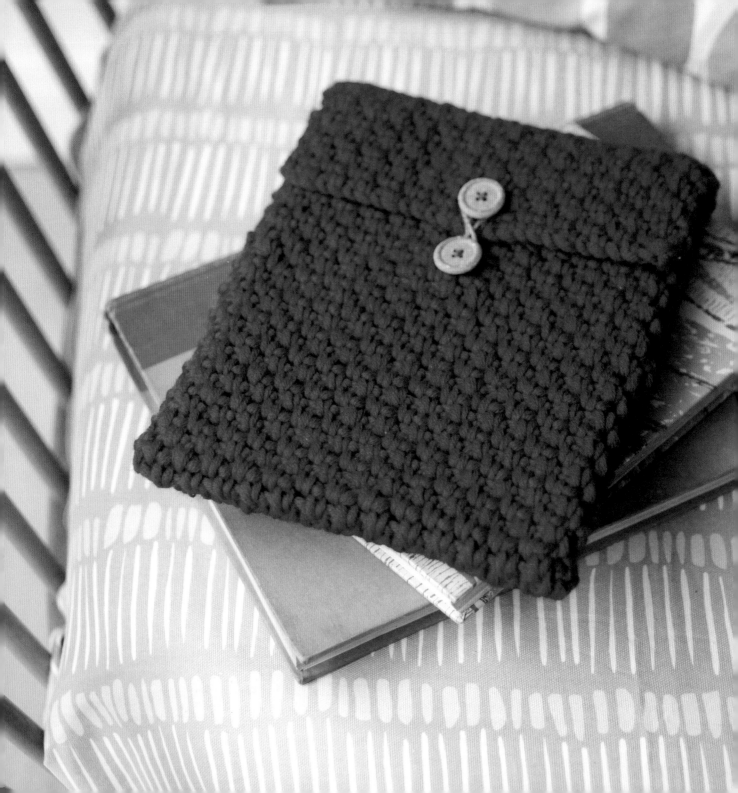

Tablet case

Every girl around town will want to show off her crochet skills with this smart tablet cover – the chunky wool yarn is the perfect protection against knocks and scratches. If you're new to crochet symbols, try reading them for this simple stitch pattern.

TO MAKE THE COVER

Foundation chain: Using 5mm (US size H/8) hook, make 28 ch.
Row 1 (RS): 1 dc in 2nd ch from hook, *1 ch, miss 1 ch, 1 dc in next ch; rep from * to end of row, turn.
Row 2: 1 ch (counts as first stitch), * 1 dc in next 1-ch space, 1 ch; rep from * to end of row, ending with 1 dc in 1-ch at end of row, turn.
Repeat Row 2 until work measures 61cm (24in).
Fasten off.

TO FINISH

Lay crochet wrong side up, with last row at the bottom. Then fold up 25cm (10in) with wrong sides together and pin – the remaining 10cm (4in) section at the top is for the envelope flap. Sew side seams from the right side with overcasting stitches.
Using sewing thread the same colour as the yarn, sew one button to the centre of the outer side of the flap, close to the flap edge. Fold the flap to the front of the case and mark the position of the second button on the case front just below the first button. Sew the second button in place.
Use a 25cm (10in) length of twine to securely close the case, wrapping it first around one button and then the other.

SUPPLIES

CROCHET HOOK:
5mm (US size H/8) crochet hook

YARN:
Mondial Yarns *Cross Chunky*, or a similar chunky-weight wool yarn, in one colour:
 1 x 100g (3½oz) ball in claret red

EXTRAS:
Two 22mm (⅞in) buttons
Sewing thread in same colour as yarn
25cm (10in) length of twine

TENSION:
13½ sts and 12 rows to 10cm (4in) measured over stitch pattern using a 5mm (US size H/8) hook.

SIZE:
Finished closed case measures 21cm (8¼in) wide x 26cm (10¼in) tall

ABBREVIATIONS:
See inside back-cover flap.

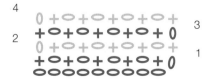

KEY
O = chain stitch
+ = double crochet

Jute shopper

Made in rugged garden twine, this quick-to-crochet bag is just the thing for a trip to the local shop. Or use it to carry around your latest crochet project. It's made in the round starting at the base, so no tricky seams. Make your next one in jolly stripes.

SUPPLIES

CROCHET HOOKS:
5mm (US size H/8) metal crochet hook
5.5mm or 6mm (US sizes I/9 or J/10) metal crochet hook – optional (see Pattern Note)

YARNS:
Nutscene *3-ply Jute Twine*, or a similar jute garden twine, in two colours:
 MC 2 x 110m (120yd) spools in light brown
 CC 1 x 110m (120yd) spool in teal

TENSION:
11 sts and 9½ rows to 10cm (4in) measured over half treble crochet using a 5mm (US size H/8) hook.

SIZE:
Finished bag is 27cm (10¾in) tall and base measures 11cm (4¼in) wide x 30cm (11¾in) long

ABBREVIATIONS:
See inside back-cover flap.

PATTERN NOTE:
You may find it too difficult to work the first round of the bag with a 5mm (US size H/8) hook; if so, use a 5.5mm (US size I/9) or a 6mm (US size J/10) hook to work the foundation chain and Round 1, then change to a 5mm (US size H/8) hook for the remainder of the bag.

TO MAKE THE BAG

The bag is made in the round, starting with the base.

Bag base

Foundation chain: Using a 5mm (US size H/8) hook and MC, make 23 ch.

Round 1 (RS): 2 dc in 2nd ch from hook, 1 dc in each of next 20 ch, 3 dc in last ch; with RS still facing, turn work so bottom of foundation ch is at top and continue along bottom of sts just made, miss ch with 3-dc group and work 1 dc in next foundation ch, 1 dc in each of next 19 ch, 1 dc in last ch (in same ch as 2-dc group), join with a sl st in top of first dc at beginning of round. (46 dc)

Continue in rounds with RS always facing.

Round 2: 1 ch (does NOT count as a stitch), 2 dc in same place as last sl st (centre dc of 3-dc group), 1 dc in each of next 22 dc, 3 dc in next dc (centre dc of 3-dc group), 1 dc in each of next 22 dc, 1 dc in next dc (same place as 2-dc group), join with a sl st in top of first dc at beginning of round. (50 dc)

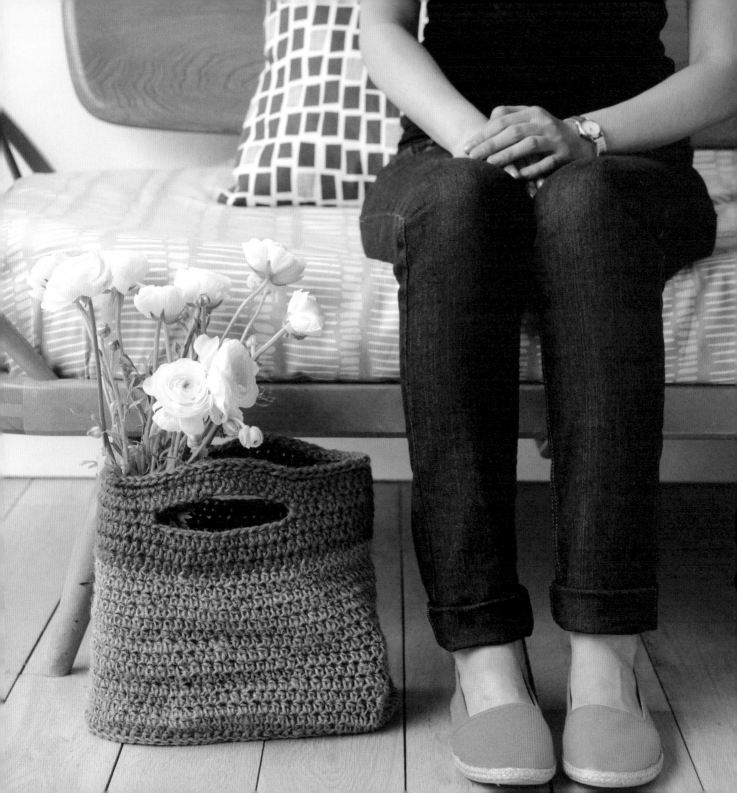

Round 3: 1 ch, 2 dc in same place as last sl st (centre dc of 3-dc group), 1 dc in each of next 24 dc, 3 dc in next dc (centre dc of 3-dc group), 1 dc in each of next 24 dc, 1 dc in next dc (same place as 2-dc group), join with a sl st in top of first dc at beginning of round. (54 dc)

Round 4: 1 ch, 2 dc in same place as last sl st (centre dc of 3-dc group), 1 dc in each of next 26 dc, 3 dc in next dc (centre dc of 3-dc group), 1 dc in each of next 26 dc, 1 dc in next dc (same place as 2-dc group), join with a sl st in top of first dc at beginning of round. (58 dc)

Round 5: 1 ch, 2 dc in same place as last sl st (centre dc of 3-dc group), 1 dc in each of next 28 dc, 3 dc in next dc (centre dc of 3-dc group), 1 dc in each of next 28 dc, 1 dc in next dc (same place as 2-dc group), join with a sl st in top of first dc at beginning of round. (62 dc)

Round 6: 1 ch, 2 dc in same place as last sl st (centre dc of 3-dc group), 1 dc in each of next 30 dc, 3 dc in next dc (centre dc of 3-dc group), 1 dc in each of next 30 dc, 1 dc in next dc (same place as 2-dc group), join with a sl st in top of first dc at beginning of round. (66 dc)

Round 7: 1 ch, 2 dc in same place as last sl st (centre dc of 3-dc group), 1 dc in each of next 32 dc, 3 dc in next dc (centre dc of 3-dc group), 1 dc in each of next 32 dc, 1 dc in next dc (same place as 2-dc group), join with a sl st in top of first dc at beginning of round. (70 dc)
This completes the bag base.

Bag sides
Continue in rounds with RS facing for sides of bag as follows:
Round 8 (RS): 2 ch (counts as first htr), *1 htr in next dc; rep from * to end of round, join with a sl st in top of 2-ch at beginning of round. (70 sts)

Round 9: 2 ch (counts as first htr), 1 htr in each htr to end of round, join with a sl st in top of 2-ch at beginning of round. (70 sts)

Rounds 10–23: [Rep Round 9] 14 times, changing to CC for last sl st of Round 23.
Cut off MC and continue with CC.

Rounds 24–26: [Rep Round 9] 3 times.
Pull up working loop on hook so crochet will not start to unravel. Then fold bag neatly in half, with side folds aligned with centre of increases on base. On last round, mark centre stitch on each side of bag – these stitches are 34 sts apart in each direction.
Place working loop back on hook, pull to tighten and continue as follows:

Round 27: 2 ch (counts as first htr), 1 htr in each st to 7 sts before centre st of first side, make 15 ch, miss next 15 sts (including next 7 sts, centre st, next 7 sts), 1 htr in each of next 20 sts, make 15 ch, miss next 15 sts, 1 htr in each st to end of round, join with a sl st to top of 2-ch at beginning of round.

Round 28: 2 ch (counts as first htr), 1 htr in each htr and in each ch to end of round, join with a sl st to top of 2-ch at beginning of round. (70 sts)

Round 29: 1 ch (does not count as a stitch), 1 dc in same place as last sl st, 1 dc in each htr to end of round, join with a sl st in top of first dc at beginning of round.

Top edging
Make a ridge edging around top as follows:
Round 30: Insert hook from front to back through space before first dc then around post of first dc and from back to front through space between this dc and next dc, yrh and draw a loop through to front of work, yrh and draw through 2 loops on hook (this completes first dc around post), work 1 dc around post of each dc to end of round, join with a sl st in top of first dc at beginning of round.
Fasten off.

TO FINISH
Sew in any loose yarn ends.
Ridge around bag base
Using 5mm (US size H/8) hook and MC, work 1 dc around post of each htr in first round of htr (Round 8). Fasten off.
Sew in remaining loose yarn ends.

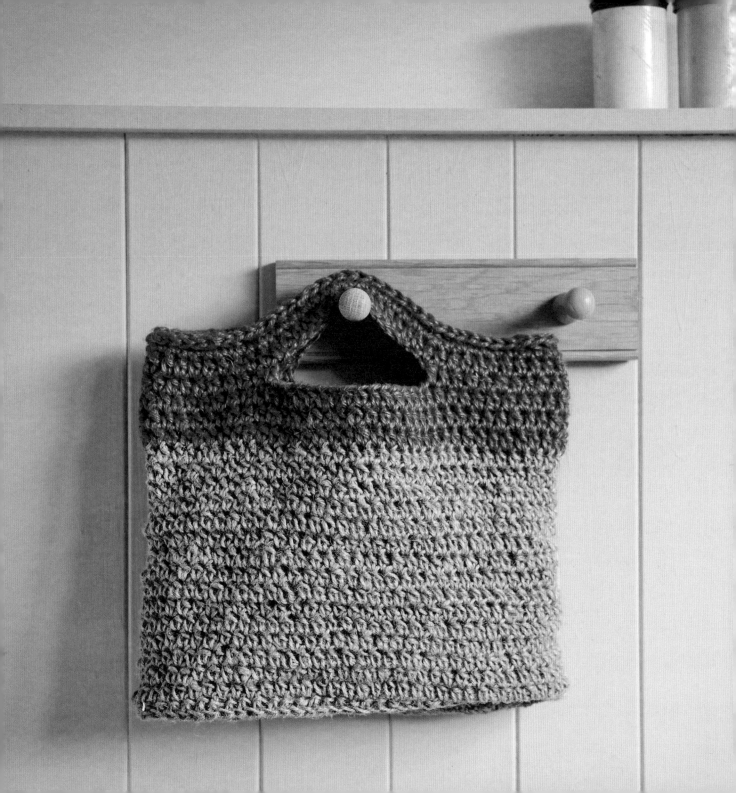

Homewares

- Clock • Pot stand
- Drum lampshade • Storage basket
- Granny throw • Tea-light cuffs
- Pebbles

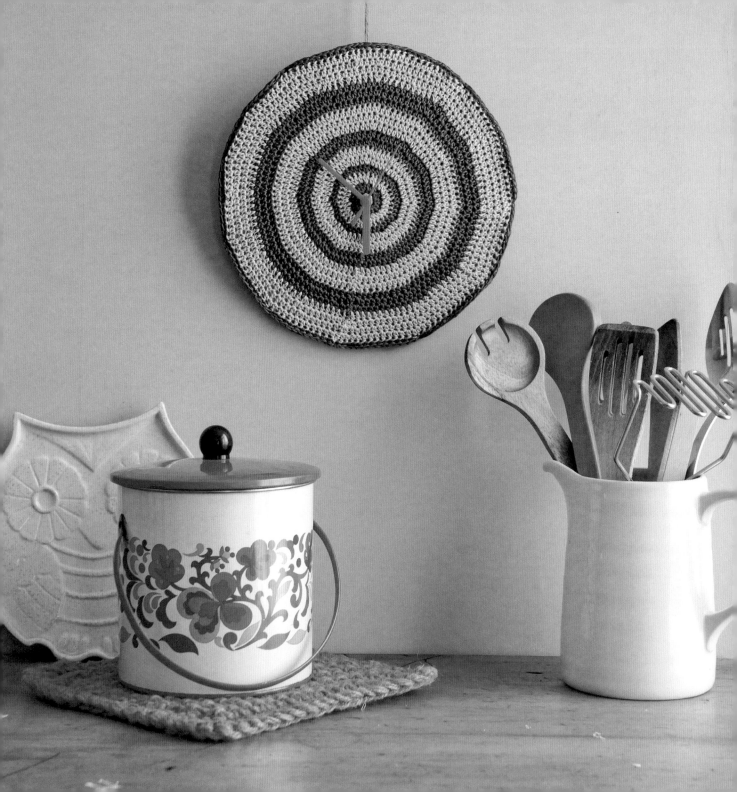

Clock

You can crochet anything – even a stylish textured clock face! Once you've mastered a double crochet circle, you'll be able to improvise designs of your own – coasters, bases for baskets, place mats or berets – all using this same basic circle pattern.

TO MAKE THE CLOCK FACE

Base ring: Using a 2.5mm (US size C/2) hook and A, make 6 ch and join with a sl st in first ch to form a ring.

Round 1 (RS): 1 ch, 12 dc in ring, join with a sl st in top of first dc at beginning of round. (12 dc)
Continue in rounds with RS of work always facing.

Round 2: 2 ch (this 2-ch counts as first htr of round throughout), 1 htr in same place as last sl st (at base of 2-ch), 2 htr in each of remaining 11 dc, join with a sl st in top of 2-ch at beginning of round. (24 sts)

Note: For neater colour changes, change to a new colour with the last slip stitch of the previous row – this way the first chain of the next round will be in the new colour.

Round 3: Change to B, 2 ch, 2 htr in first htr, *1 htr in next htr, 2 htr in next htr; rep from * to end, join with a sl st in top of 2-ch. (36 sts)

Round 4: Change to A, 2 ch, 1 htr in first htr, 2 htr in next htr, *1 htr in each of next 2 htr, 2 htr in next htr; rep from * to end, join with a sl st in top of 2-ch. (48 sts)

Round 5: Change to B, 2 ch, 1 htr in each of next 2 htr, 2 htr in next htr, *1 htr in each next 3 htr, 2 htr in next htr; rep from * to end, join with a sl st in top of 2-ch. (60 sts)

Round 6: 2 ch, 1 htr in each of next 3 htr, 2 htr in next htr, *1 htr in each of next 4 htr, 2 htr in next htr; rep from * to end, join with a sl st in top of 2-ch. (72 sts)

Round 7: Change to A, 2 ch, 1 htr in each of next 4 htr, 2 htr in next htr, *1 htr in each of next 5 htr, 2 htr in next htr; rep from * to end, join with a sl st in top of 2-ch. (84 sts)

Round 8: 2 ch, 1 htr in each htr to end, join with a sl st in top of 2-ch.

Round 9: Change to B, 2 ch, 1 htr in each of next 5 htr, 2 htr in next htr, *1 htr in each of next 6 htr, 2 htr in

SUPPLIES

CROCHET HOOK:
2.5mm (US size C/2) crochet hook

YARNS:
Yeoman Yarns *Cannele 4-ply*, or a similar super-fine-weight mercerised cotton yarn, in two colours:
 A 1 x 245g (8¾oz) cone in grey
 B 1 x 245g (8¾oz) cone in linen

EXTRAS:
Circle of thin wood or foam board 1cm (⅜in) smaller in diameter than finished circle of crochet
Clock workings

TENSION:
21 sts and 15 rows to 10cm (4in) measured over half treble crochet using a 2.5mm (US size C/2) hook.

SIZE:
Finished clock cover measures 26cm (10¼in) in diameter

ABBREVIATIONS:
See inside back-cover flap.

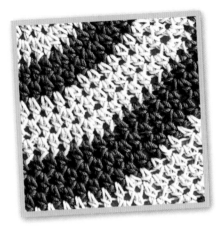

THE HALF TREBLE CROCHET FORMS A NICE DENSE TEXTURE FOR THE CLOCK COVER.

next htr; rep from * to end, join with a sl st in top of 2-ch. (96 sts)

Round 10: Rep Round 8.

Round 11: 2 ch, 1 htr in each of next 6 htr, 2 htr in next htr, *1 htr in each of next 7 htr, 2 htr in next htr; rep from * to end, join with a sl st in top of 2-ch. (108 sts)

Round 12: Change to A and rep Round 8.

Round 13: 2 ch, 1 htr in each of next 7 htr, 2 htr in next htr, *1 htr in each of next 8 htr, 2 htr in next htr; rep from * to end, join with a sl st in top of 2-ch. (120 sts)

Round 14: Rep Round 8.

Round 15: Change to B, 2 ch, 1 htr in each of next 8 htr, 2 htr in next htr, *1 htr in each of next 9 htr, 2 htr in next htr; rep from * to end, join with a sl st in top of 2-ch. (132 sts)

Round 16: Rep Round 8.

Round 17: 2 ch, 1 htr in each of next 9 htr, 2 htr in next htr, *1 htr in each of next 10 htr, 2 htr in next htr; rep from * to end, join with a sl st in top of 2-ch. (144 sts)

Round 18: Rep Round 8.

Round 19: Change to A, 1 ch (does NOT count as a stitch), 1 dc in same place as last sl st, 1 dc in each htr to end, join with a sl st in top of first dc. (144 dc)

Ridge edging

Make a ridge edging around outside edge as follows:

Round 20: Insert hook from front to back through space before first dc then around post of first dc and from back to front through space between this dc and next dc, yrh and draw a loop through to front of work, yrh and draw through 2 loops on hook (this completes first

dc around post), work 1 dc around post of each dc to end of round, join with a sl st in top of first dc at beginning of round.

Fasten off.

TO MAKE THE CLOCK

Sew in any loose yarn ends.

Place your crochet over a disc of wood or thick foam board slightly smaller than the crochet circle. Make sure there is a hole drilled at the centre and that this is the same size as the thread stem of your clock mechanics.

Using a blunt-ended yarn needle and long length of A, stitch across the back of the wood or foam-board disc to form a web that holds the crochet firmly in place.

Attach the clock workings and hands as explained in the instructions with the clock.

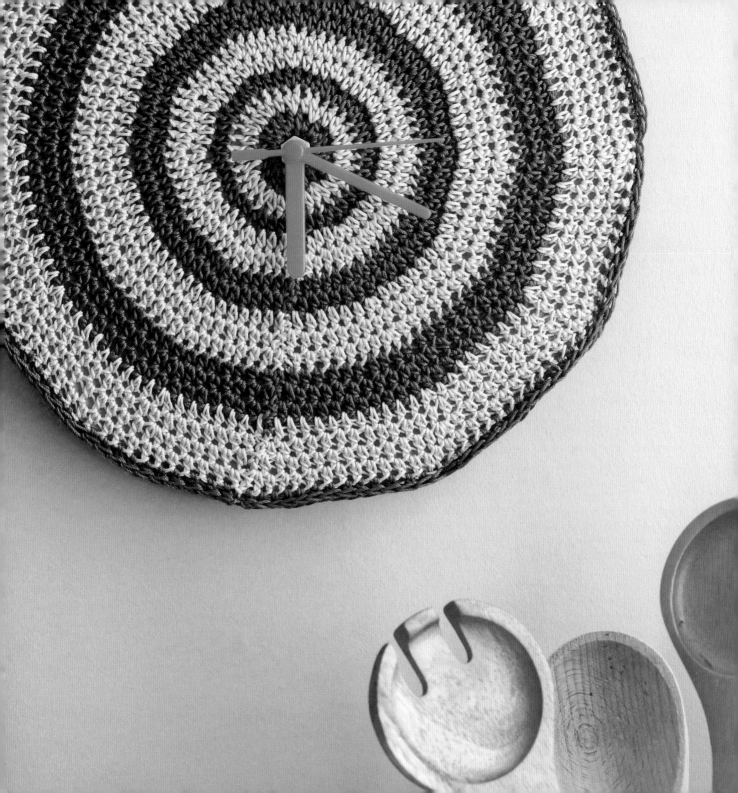

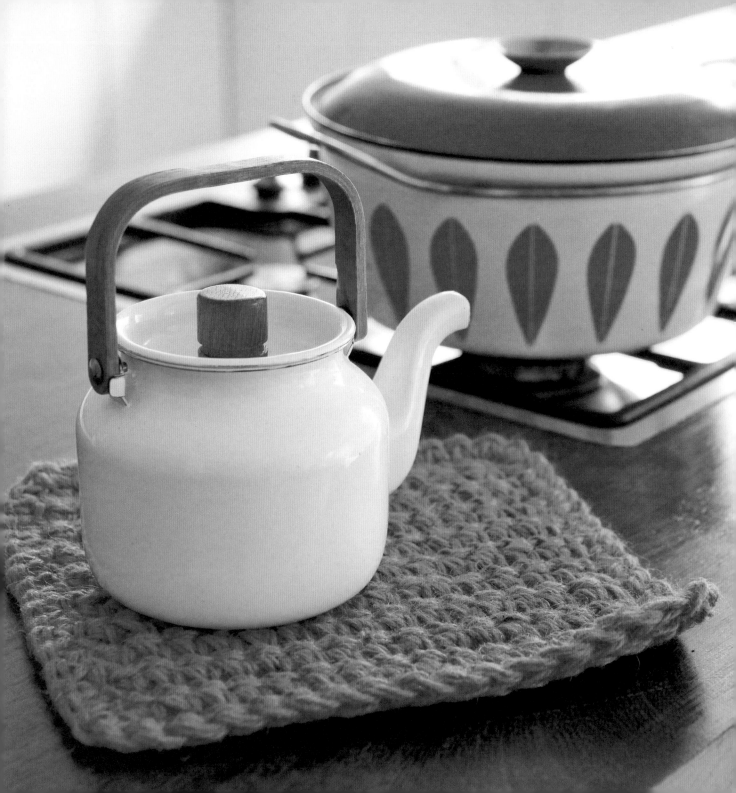

Pot stand

The attractive crochet textures of this mat are created simply by working into the back loops of the double crochet stitches on every other row. Using two strands of jute twine produces distinctive chunky stitches. Make several to match your pots.

TO MAKE THE POT STAND

Foundation chain: Using 7mm (US size K/10½) hook and twine double, make 17 ch.

Row 1 (RS): 1 dc in 2nd ch from hook, 1 dc in each of remaining ch to end, turn. (16 dc)

Row 2 (RS): 1 ch (does NOT count as a stitch), then working in back loop only (this forms the ridge), work 1 dc in each dc to end, turn.

Row 3: 1 ch, then working in both loops in the usual way, work 1 dc in each dc to end, turn.

Rows 4–19: [Rep Rows 2 and 3] 8 times.

Row 20 (RS): Rep Row 2, but do not turn work at end of row.
Do not cut off twine, but work edging as follows.

Edging

With RS still facing (the ridged side), work 2 dc at end of Row 20 in corner, then work dc evenly along the side edge, work 2 dc in corner, work 1 dc between each pair of dc along underside of foundation-chain edge, work 2 dc in corner, work dc evenly along the other side edge, work 2 dc in corner, join with a sl st to first dc of last row.
Fasten off.

TO FINISH

Sew in any loose yarn ends.

SUPPLIES

CROCHET HOOK:
7mm (US size K/10½) crochet hook

YARN:
Nutscene *3-ply Jute Twine*, or a similar jute garden twine, in one colour:
 1 x 110m (120yd) spool in terracotta

TENSION:
7 sts and 8½ rows to 10cm (4in) measured over pattern using 7mm (US size K/10½) hook and 2 strands of twine held together.

SIZE:
25cm (10in) square

ABBREVIATIONS:
See inside back-cover flap.

YARN NOTE:
The pot stand requires approximately three-quarters of the 110m (120yd) spool, or approximately 83m (91yd). Use two strands of the twine held together throughout.

EACH SIDE OF THE STITCH PATTERN HAS A UNIQUE TEXTURE, SO IT CAN BE USED EITHER WAY UP.

Drum lampshade

Here's how to crochet an openwork cover for any size of drum lampshade. Pick a colour to go with your décor and have a go. The maths involved is fairly simple and the crochet couldn't be much easier. There's even a stitch diagram to guide your efforts.

SUPPLIES

Crochet hooks:
3mm and 3.5mm (US sizes D/3 and E/4) crochet hooks

Yarn:
Yeoman Yarns *DK Soft Cotton*, or a similar lightweight matt cotton yarn, in one colour:
 1 x 450g (15⅞oz) cone in charcoal

Extras:
Drum lampshade in desired size

Tension:
18 sts and 12 rows to 10cm (4in) measured over stitch pattern using a 3.5mm (US size E/4) hook.

Size:
Lampshade cover shown measures 63cm (24¾in) in diameter by 28cm (11in) tall, but the cover can be made to fit your own drum lampshade

Abbreviations:
See inside back-cover flap.

Yarn note:
The cover shown used 110g (3⅞oz) of yarn – or 220m (240½yd). So the 450g (15⅞oz) cone is enough for a larger drum lampshade.

TO FIT THE STITCH PATTERN TO YOUR LAMPSHADE

The instructions are for a lampshade 28cm (11in) tall and 63cm (24¾in) in diameter. To determine how many foundation chain to start with for a drum lampshade of a different size, first measure the height of the lampshade. Subtract 2cm (¾in) from the total height; this amount will be added by the edging along the row-end edges of the crochet, which runs along the top and bottom edges of the cover – each of these borders is 1cm (⅜in) wide. Then use the tension to work out the number of stitches you need; the stitch pattern is worked over a multiple of 3 stitches plus 2 extra stitches, so make sure the number of stitches you want is a multiple of 3 plus 2 – it is better to make the piece a little wider rather than a little narrower, so that it will definitely cover the height of your lampshade. The calculated number is the number of double crochet stitches needed in the first row of the stitch pattern. Add one to this number for the number of chains for your foundation chain.

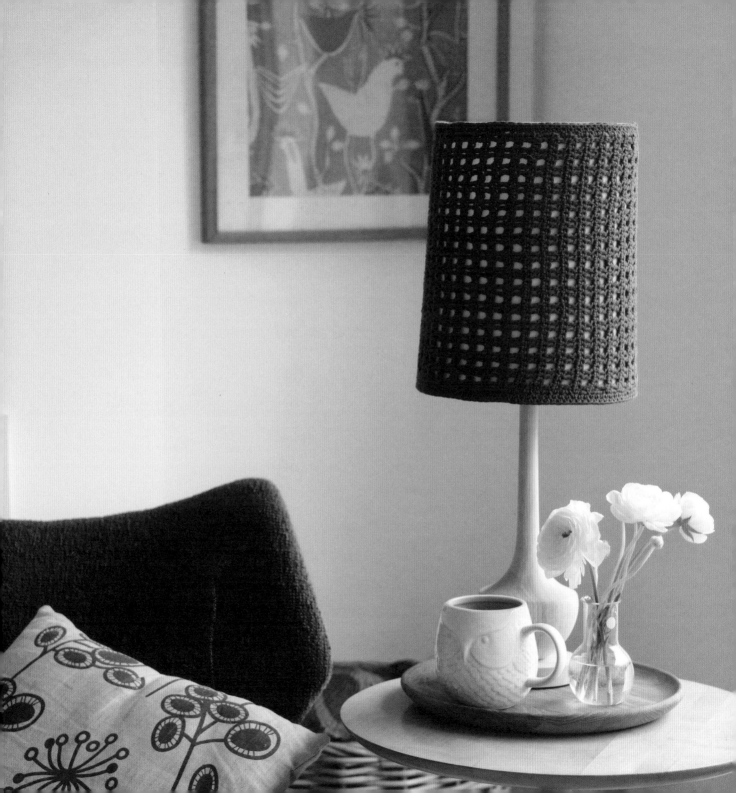

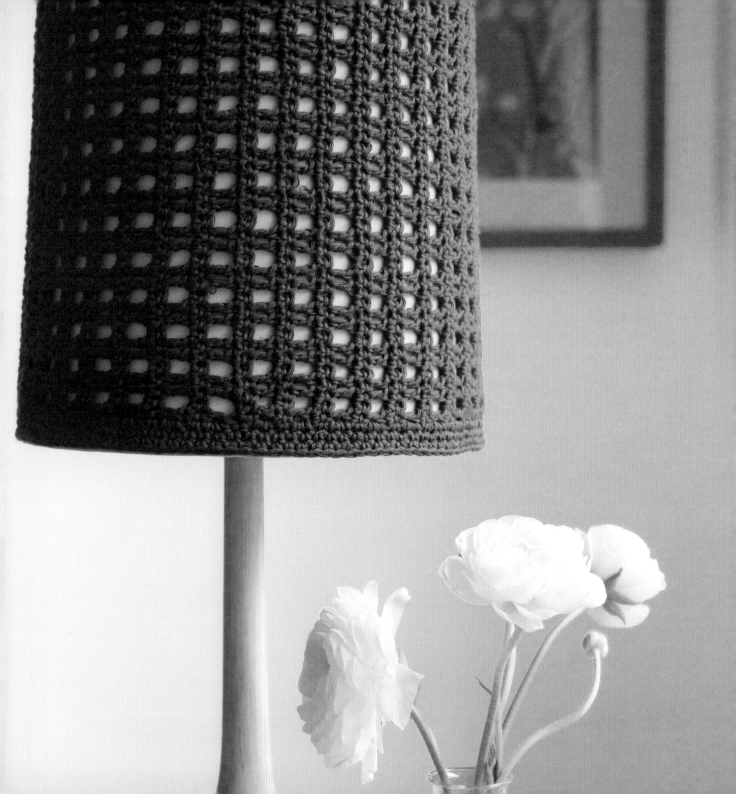

TO MAKE THE LAMPSHADE COVER

Foundation chain: Using a 3.5mm (US size E/4) hook, make 48 ch for a 28cm (11in) tall lampshade – or the number of chain you have calculated for a lampshade of a different height.

Row 1 (WS): 1 dc in 2nd ch from hook, 1 dc in each of remaining ch to end, turn. (47 dc – or number of stitches needed for a lampshade of a different height)

Row 2 (RS): 3 ch (counts as 1 tr), miss first dc, 1 tr in next dc, *1 ch, miss 1 dc, 1 tr in each of next 2 dc; rep from * to end of row, turn. (47 sts – counting first 3-ch as a st, and counting each tr and each ch as a st)

Row 3: 1 ch (does NOT count as a stitch), 1 dc in each of first 2 tr, *1 dc in next 1-ch sp, 1 dc in each of next 2 tr; rep from * to last 1-ch sp, 1 dc in last 1-ch sp, 1 dc in last tr, 1 dc in top of 3-ch at end, turn. Repeat rows 2 and 3 until work stretches evenly around your lampshade, ending with a Row 2. Fasten off.

TO FINISH

With right sides together, sew foundation-chain edge to top of last row of crochet piece.

Edging

Work the edging around each row-end edge as follows:

Round 1 (RS): Using a 3mm (US size D/3) hook and with RS of work facing, join yarn with a sl st in one row-end edge of lampshade cover at seam, 1 ch, 1 dc in same place as sl st, work dc evenly along this edge (1 dc in every dc row end and 2 dc in every tr row end), join with a sl st in top of first dc at beginning of round.

Continue in rounds with RS of work always facing.

Round 2: 1 ch, 1 dc in same place as last sl st, 1 dc in each dc to end of round, join with a sl st in top of first dc at beginning of round.

Round 3: Rep Round 2.

Fasten off.

Work 3 rounds of dc along the other row-end edge in the same way.

Sew in any loose yarn ends. Slip onto lampshade.

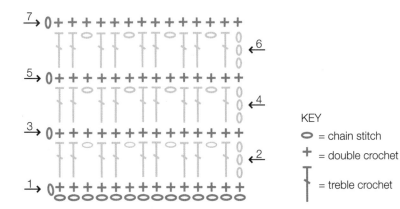

KEY

○ = chain stitch

+ = double crochet

T = treble crochet

Storage basket

What better place to store your crochet projects than a sturdy half treble crochet basket? Made in giant stitches with cotton jersey fabric strips, it takes shape in a flash. You'll soon find you need one for every room in the house for all those other odds and ends.

TO MAKE THE BASKET

Base ring: Using a 7mm (US size K/10½) hook and MC, make 4 ch and join with a sl st in first ch to form a ring.

Round 1 (RS): 2 ch (counts as 1 htr), 9 htr in ring, join with a sl st in 2-ch at beginning of round. (10 sts)
Continue in rounds with RS always facing.
Counting 2-ch at beginning of each round as 1 stitch, work as follows:

Round 2: 2 ch, 1 htr in space between 2-ch in round below and first htr, [2 htr in space between next 2 htr] 8 times, 2 htr in space between last htr and 2-ch in round below, join with sl st in 2-ch at beginning of round. (20 sts)

Round 3: 2 ch, 1 htr in space between 2-ch in round below and first htr, *1 htr in space between next 2 htr, 2 htr in space between next 2 htr; rep from * to last htr, 1 htr in space between last htr and 2-ch in round below, join with sl st in 2-ch at beginning of round. (30 sts)

Round 4: 2 ch, 1 htr in space between 2-ch in round below and first htr, *[1 htr in space between next 2 htr] twice, 2 htr in space between next 2 htr; rep from * to last 2 htr, 1 htr in space between next 2 htr, 1 htr in space between last htr and 2-ch in round below, join with sl st in 2-ch at beginning of round. (40 sts)
This completes the base of the basket.

Round 5: 2 ch, *1 htr in space between next 2 htr; rep from *, ending with 1 htr in space between last htr and 2-ch in round below, join with sl st in 2-ch at beginning of round. (40 sts)

Rounds 6–10: [Rep Round 5] 5 times, changing to CC with sl st at end of Round 10.
Cut off MC and continue with CC.

Round 11: 1 ch, *1 dc in space between next 2 htr; rep from *, ending with 1 dc in space between last htr and 2-ch in round below, join with sl st in top of dc at beginning of round. (40 dc)
Fasten off.

TO FINISH
Sew in any loose yarn ends.

SUPPLIES

CROCHET HOOK:
7mm (US size K/10½) crochet hook

YARNS:
Hoopla Yarn, or a similar super-chunky-weight yarn made from approximately 1cm- (⅜in-) wide selvedge edges from jersey fabric, in two colours:
 MC 1 x 500g (17⅝oz) cone in mid grey
 CC Small amount in yellow or other contrasting colour

TENSION:
7 sts and 6 rows to 10cm (4in) measured over stitch pattern using a 7mm (US size K/10½) hook.

SIZE:
Approximately 18cm (7in) in diameter x 11cm (4¼in) tall

ABBREVIATIONS:
See inside back-cover flap.

YARN NOTE:
The cover shown used 350g (12⅜oz) of yarn – or 70m (76½yd). So the 500g (17⅝oz) cone is enough for a taller or wider basket.

Granny throw

Granny knew this traditional crochet blanket wouldn't be out of fashion long. It's cosy, comforting, full of vibrant colour, and making one is an ecological way to use up left over – or even recycled – yarns. The squares are easy to make as well!

TO MAKE THE GRANNY SQUARES

Make any number of squares to make up a throw, this one uses a total of 272 squares – 17 horizontal rows of squares, each 16 squares across.

Using three different colours for the first 3 rounds and black for the last round of each square, work each square as follows:

Base ring: Using a 3mm (US size D/3) hook and colour 1, make 6 ch and join with a sl st in first ch to form a ring.

Round 1 (RS): 3 ch (counts as first tr), 3 tr in ring, [3 ch, 4 tr in ring] 3 times, 3 ch, join with sl st in top of 3-ch at beginning of round. Fasten off.

Continue in rounds with RS always facing.

Round 2: With RS facing, join colour 2 with a sl st in any 3-ch space, 3 ch (counts as first tr), [3 tr, 3 ch, 4 tr] in same 3-ch space (first corner), *1 ch, [4 tr, 3 ch, 4 tr] in next 3-ch space (corner); rep from * twice more, 1 ch, join with sl st in top of 3-ch at beginning of round. Fasten off.

Round 3: With RS facing, join colour 3 with a sl st in any 3-ch corner space, 3 ch (counts as first tr), [3 tr, 3 ch, 4 tr] in same 3-ch corner space, *1 ch, 4 tr in next 1-ch space, 1 ch, [4 tr, 3 ch, 4 tr] in next 3-ch corner space; rep from * twice more, 1 ch, 4 tr in next 1-ch space, 1 ch, join with sl st in top of 3-ch at beginning of round. Fasten off.

Round 4: With RS facing, join black with a sl st in any 3-ch corner space, 3 ch (counts as first tr), [3 tr, 3 ch, 4 tr] in same 3-ch corner space, *[1 ch, 4 tr in next 1-ch space] twice, 1 ch, [4 tr, 3 ch, 4 tr] in next 3-ch corner space; rep from * twice more, [1 ch, 4 tr in next 1-ch space] twice, 1 ch, join with sl st in top of 3-ch at beginning of round. Fasten off.

Sew in any loose ends after finishing each square.

CROCHET HOOK:
3mm (US size D/3) crochet hook

YARNS:
A 4-ply wool yarn (a super-fine-weight yarn) in black for granny square borders and throw borders, and scraps of many colours in same yarn weight for making granny squares

TENSION:
Each granny square measures 9cm x 9cm (3½in x 3½in) using a 3mm (US size D/3) hook.

SIZE:
The throw can be made to any size

ABBREVIATIONS:
See inside back-cover flap.

YARN NOTE:
This throw was made mostly from 4-ply wool yarn, a super-fine-weight yarn, although there is a small amount of double-knitting-weight yarn mixed in, too. It is okay to add in a slightly thicker yarn now and then with this kind of project that uses up ends of yarn.

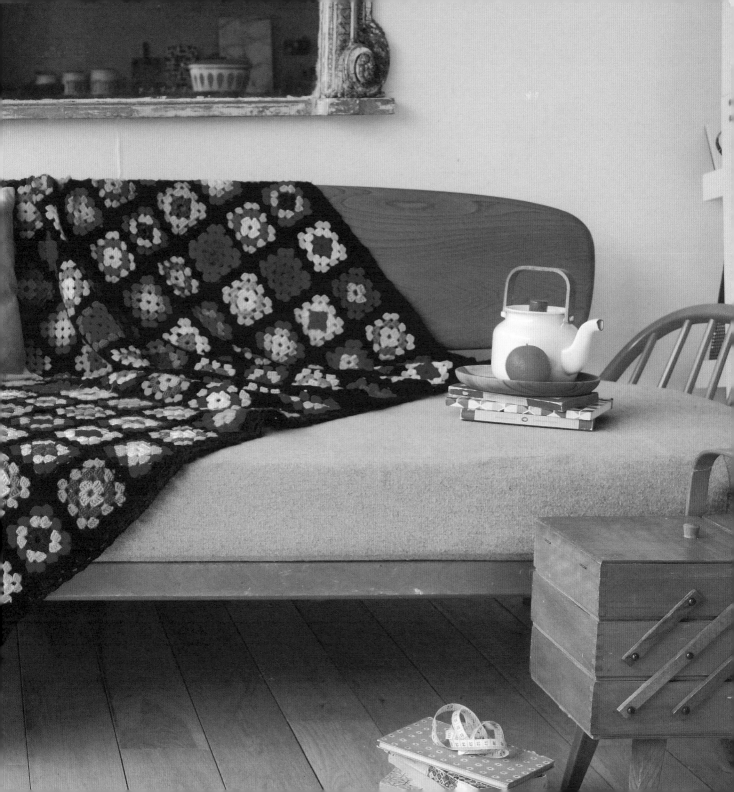

TO FINISH

Lay out your squares making sure that the colours work well together. Catch stitch your squares together from side to side using a blunt-ended yarn needle and black yarn.

Border

When all the squares are stitched together, you can work a border all around the blanket.

Using a 3mm (US size D/3) hook and black, work border as follows:

Round 1 (RS): Join yarn with a sl st in any 3-ch corner of throw, 3 ch (counts as first tr), [2 tr, 1 ch, 3 tr] in same 3-ch corner space, *miss next tr, 1 tr in each of next 2 tr, [2 tr in next 1-ch space, miss next tr, 1 tr in each of next 2 tr] 3 times**, 2 tr in last ch space of this square,

1 tr in first ch space of next square; rep from * to next corner of throw ending last repeat at **, [3tr, 1 ch, 3 tr] in 3-ch corner space, then continue from first * all the way around throw, join with a sl st in top of first 3-ch at beginning of round.

Round 2: 3 ch, work 1 tr in each tr all around blanket, working [3tr, 1 ch, 3 tr] in each of the four 1-ch corner spaces when they are reached, join with a sl st in top of first 3-ch at beginning of round.

Round 3: 3 ch, 3 tr in space between 3-ch in round below and first tr from Round 2, *miss next 4 tr, [3 tr, 1 ch, 3 tr] in first 1-ch corner space, *miss next 4 tr, 4 tr in space between last missed tr and next tr; rep from * all around throw, but working [3 tr, 1 ch, 3 tr] in each corner, join with a sl st in top of 3-ch at beginning of round.
Fasten off.
Sew in any loose yarn ends.

KEY

• = slip stitch

◯ = chain stitch

T = treble crochet

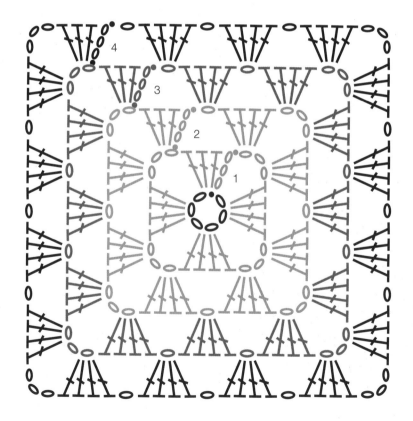

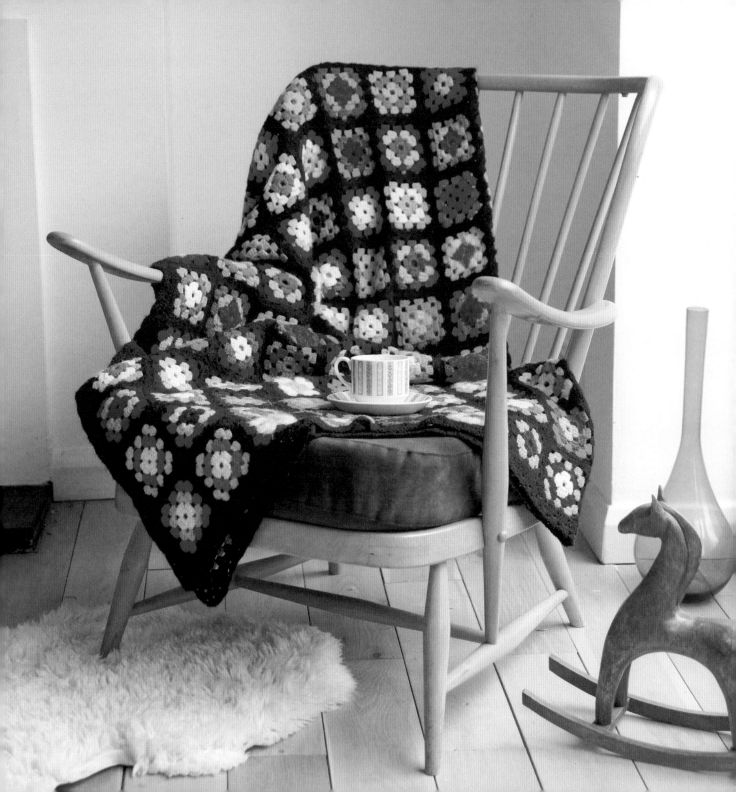

Tea-light cuffs

Set the tone for a romantic night in with a host of these decorative candle holders. They are recycled glass jars covered with lacy mercerised cotton crochet cuffs. Each cuff is made up of three crochet motifs that are stitched together to form a tube.

SUPPLIES

CROCHET HOOK:
2mm (US size B/1) crochet hook

YARNS:
Yeoman Yarns *Cannele 4-ply*, or a similar super-fine-weight mercerised cotton yarn, in one colour for each cuff:
Small amount in linen or dusky green

EXTRAS:
Glass tea-light holders approximately 24cm (9½in) in diameter – such as a recycled jam jar

TENSION:
Each square motif measures 7cm (2¾in) square using a 2mm (US size B/1) hook.

SIZE:
Finished cuff (unstretched) measures approximately 21cm (8¼in) around x 8cm (3¼in) wide – slightly stretched it fits a tea-light holder 24cm (9½in) in diameter

ABBREVIATIONS:
2-tr cluster: [Yrh and insert hook in space (or st), yrh and draw a loop through, yrh and draw through first 2 loops on hook] twice in same space (or st), yrh and draw through all 3 loops on hook.
3-tr cluster: [Yrh and insert hook in space (or st), yrh and draw a loop through, yrh and draw through first 2 loops on hook] 3 times in same space (or st), yrh and draw through all 4 loops on hook.
See also inside back-cover flap.

YARN NOTE:
Each cuff motif requires approximately 14g of yarn – or 49m (55½yd).

TO MAKE THE SQUARE MOTIF (MAKE 3)
Base ring: Using a 2mm (US size B/1) hook, make 4 ch and join with a sl st in first ch to form a ring.
Round 1 (RS): 1 ch, [1 dc in ring, 9 ch] 8 times, join with a sl st in top of first dc at beginning of round. (Eight 9-ch loops)
Continue in rounds with RS of work always facing.
Round 2: 1 sl st in each of first 3 ch of first 9-ch loop, 3 ch, [2-tr cluster, 3 ch, 3-tr cluster] all in same 9-ch loop (first corner), *4 ch, 1 dc in next 9-ch loop, 4 ch, [3-tr cluster, 3 ch, 3-tr cluster] in next 9-ch loop (corner); rep from * twice more, 4 ch, 1 dc in next 9-ch loop, 4 ch, join with a sl st in top of first 2-tr cluster at beginning of round.
Round 3: 1 sl st to first 3-ch space, 3 ch, [2-tr cluster, 3 ch, 3-tr cluster] all in same 3-ch space (first corner), *4 ch, 3-tr cluster in next dc, 4 ch, [3-tr cluster, 3 ch, 3-tr cluster] in next 3-ch space (corner); rep from * twice more, 4 ch, 3-tr cluster in next dc, 4 ch, join with a sl st in top of first 2-tr cluster at beginning of round.

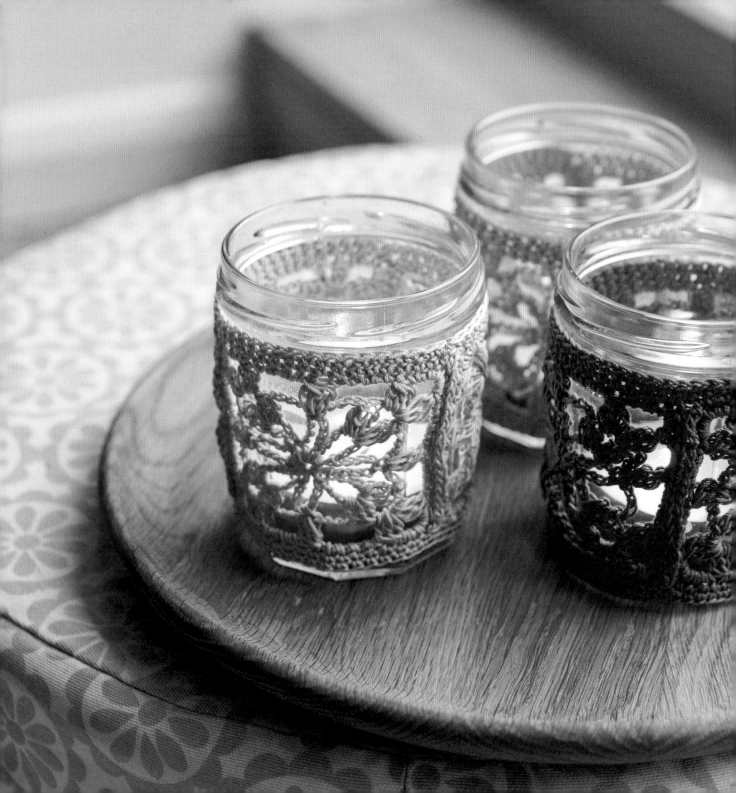

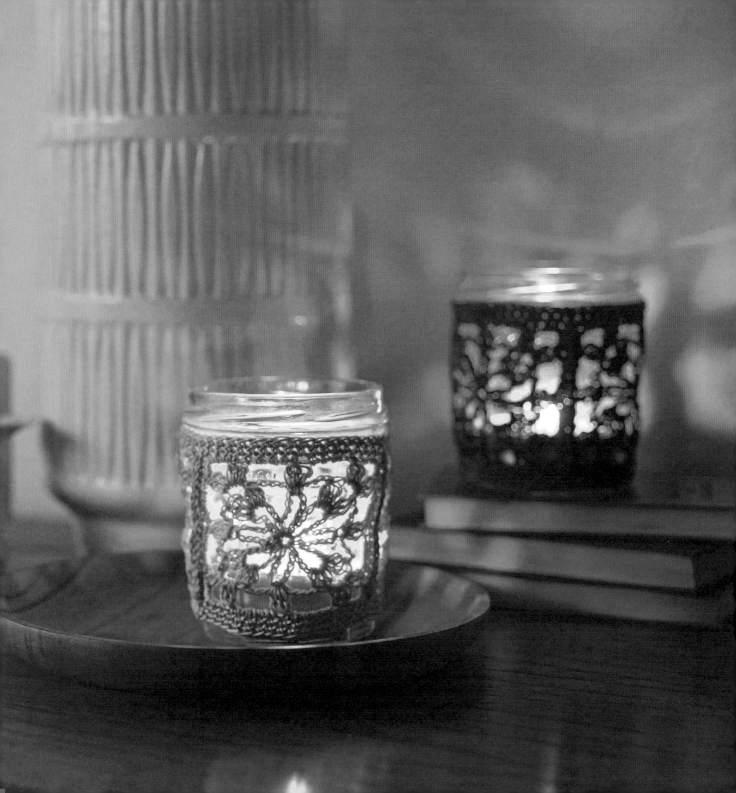

Round 4: 1 ch, 1 dc in same place as last sl st, [3 dc, 1 ch, 3 dc] in next 3-ch space (first corner), 1 dc in next cluster, *4 dc in next 4-ch space, 1 dc in next cluster, 4 dc in next 4-ch space, 1 dc in next cluster, [3 dc, 1 ch, 3 dc] in next 3-ch space (corner), 1 dc in next cluster; rep from * twice more, 4 dc in next 4-ch sp, 1 dc in next cluster, 4 dc in last 4-ch space, join with a sl st in top of first dc at beginning of round. Fasten off.
Make three motifs for each cuff.

TO FINISH

Place two motifs wrong sides together and, beginning at the corner (the 1-ch space between the two 3-dc groups), slip stitch together just under the tops of the dc along one side only, ending at the next corner (in the 1-ch space). Fasten off.

Then join the third motif wrong sides together to the second motif in the same way. Finally, join the third motif to the first motif, again with slip stitches.

Top edging

With RS facing and using a 2mm (US size B/1) hook, work a dc edging around top of cuff as follows:
Round 1 (RS): Join yarn with a sl st in top edge at seam, 1 ch, 1 dc in same place as sl st, [1 dc in each dc to next seam, 1 dc in seam] twice, 1 dc in each dc to end of round, join with a sl st in top of first dc at beginning of round.
Continue in rounds with RS facing.
Round 2: 1 ch, 1 dc in same place as last sl st, 1 dc in each dc to end of round, join with a sl st in top of first dc at beginning of round.
Fasten off.

Bottom edging

Work edging around bottom of cuff as for top edging.
Sew in any loose yarn ends.

KEY

- • = slip stitch
- ⌒ = chain stitch
- + = double crochet
- ⫪ = 2-tr cluster
- ⫫ = 3-tr cluster

Pebbles

The open spaces within these crochet motifs allows the natural beauty of the sand and sea-smoothed pebbles to show through, enhanced by the textural contrast of the stone and the shiny crocheted mercerised cotton.

SUPPLIES

CROCHET HOOKS:
2mm and 2.5mm (US sizes B/1 and C/2) crochet hooks

YARNS:
Yeoman Yarns *Cannele 4-ply,* or a similar super-fine-weight mercerised cotton yarn, in three colours:
A 15g (53m/58yd) in raspberry
B 15g (53m/58yd) in tangerine
C 15g (53m/58yd) in bright yellow

TENSION:
Working to an exact tension is not important for this project, as the crochet is worked to fit your pebble.

SIZES:
Shells pebble cover: Fits a large pebble 13cm (5in) in diameter and 4cm (1½in) thick, but can be adjusted for a slightly smaller pebble.

Star pebble cover: Fits a large pebble 13cm (5in) in diameter and 4cm (1½in) thick, but can be adjusted for a slightly smaller pebble.

Wagon wheel pebble cover: Fits a large pebble 10cm (4in) in diameter and 3cm (1¼) thick, but can be adjusted for a slightly smaller pebble.

ABBREVIATIONS:
3-trtr cluster: *Yrh 3 times and insert hook in next st, yrh and draw a loop through, [yrh and draw through first 2 loops on hook] 3 times; rep from * twice more, yrh and draw through all 4 loops on hook.

4-trtr cluster: *Yrh 3 times and insert hook in next st, yrh and draw a loop through, [yrh and draw through first 2 loops on hook] 3 times; rep from * 3 times more, yrh and draw through all 5 loops on hook.
See also inside back-cover flap.

TO MAKE THE SHELLS PEBBLE COVER
Note: Follow these instructions for a large pebble 13cm (5in) in diameter. For smaller pebbles, when you have reached the diameter skip to round 6 and work chain arches between treble and chain spaces, fewer chains for smaller stones. See page 94 for stitch diagram.

Base ring: Using a 2.5mm (US size C/2) hook and A, make 8 ch and join with a sl st in first ch to form a ring.

Round 1 (RS): 1 ch (does NOT count as a stitch), 20 dc in ring, join to with a sl st in top of first dc at beginning of round.
Cont in rounds with RS of work always facing.

Round 2: 3 ch (counts as 1 tr), 1 tr in same place as last sl st, *2 ch, miss 1 dc, 2 tr in next dc; rep from * 8 times more, 2 ch, join with a sl st in top of 3-ch at beginning of round. (Ten 2-ch spaces)

Round 3: 3 ch (counts as 1 tr), 2 tr in space between 3-ch and first tr of Round 2, *3 ch, 3 tr in space between sts of next 2-tr group; rep from * 8 times more, 3 ch, join with a sl st in top of 3-ch at beginning of

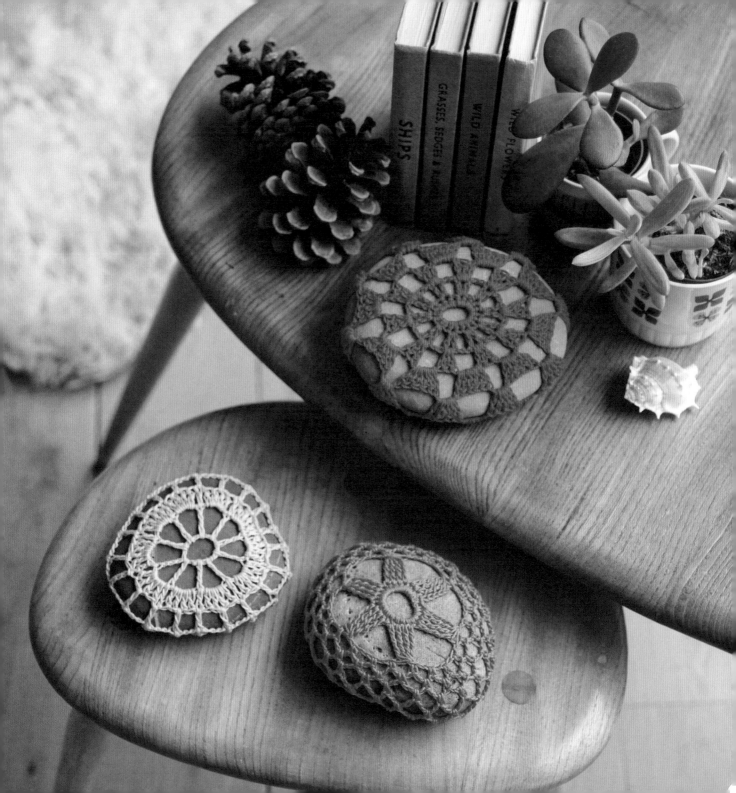

round. (Ten 3-ch spaces)
Round 4: 6 ch (counts as 1 tr and a 3-ch space) , *5 tr in next 3-ch space, 3 ch; rep from * 8 times more, 4 tr in last 3-ch space, join with a sl st in 3rd of 6-ch at beginning of round.
Round 5: 4 ch (counts as 1 dtr), 4 dtr in next 3-ch space, *3 ch, 5 dtr in next 3-ch space; rep from * 8 times more, 3 ch, join with a sl st in top of 4-ch at beginning of round.
Round 6: 1 sl st in each of first 4 dtr, 1 sl st in next 3-ch space, 4 ch (counts as 1 dtr), 5 dtr in same space, *3 ch, 6 dtr in next 3-ch space; rep from * 8 times more, 3 ch, join with a sl st in top of 4-ch at beginning of round.
Round 7: 10 ch, miss 4 dtr, 1 sl st in next dtr (last dtr of this dtr group), *10 ch, miss next 3-ch space, 1 sl st in next dtr (first dtr of next 6-dtr group), 10 ch, miss 4 dtr, 1 sl st in next dtr (last dtr of same 6-dtr group); rep from * to last 3-ch space, 10 ch, join with a sl st in base of first 10-ch at beginning of round. (20 loops)
Round 8: 1 sl st in each of first 5 ch of first 10-ch loop, *5 ch, 1 sl st in centre of next 10-ch loop; rep from * to end.
Cut off yarn, leaving a tail at least 25cm (10in) long, and fasten off. Finish as explained on page 99.

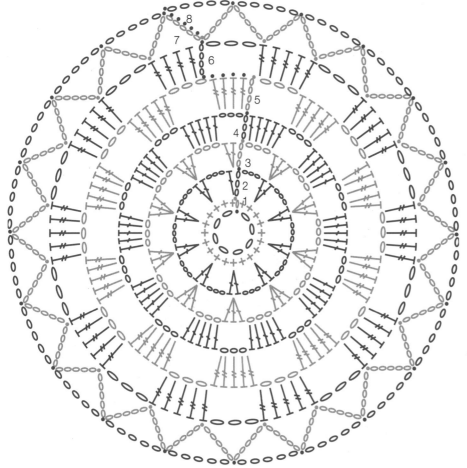

KEY

•	= slip stitch
o	= chain stitch
+	= double crochet
⊤	= treble cluster
⊤	= double treble

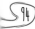

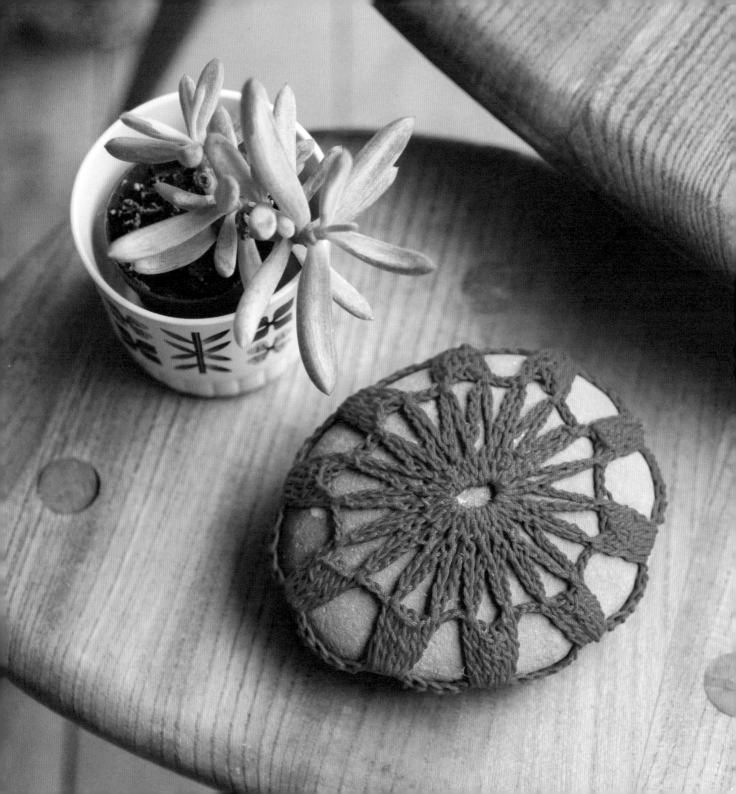

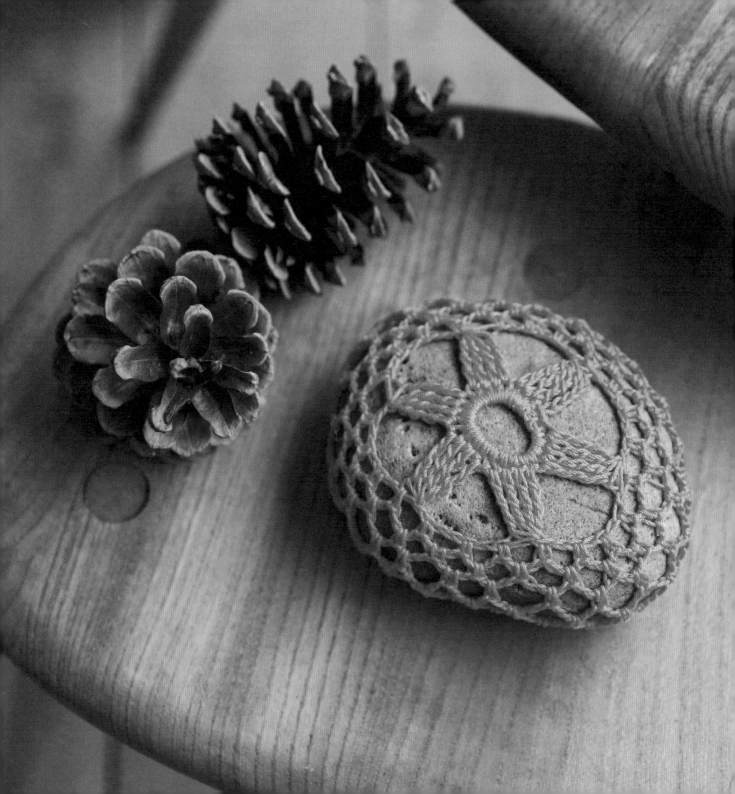

TO MAKE THE STAR PEBBLE COVER

Note: Follow these instructions for a large pebble 13cm (5in) in diameter. For smaller pebbles, work fewer chain-loop rounds.

Base ring: Using a 2mm (US size B/1) hook and B, make 16 ch and join with a sl st in first ch to form a ring.

Round 1 (RS): 1 ch (does NOT count as a stitch), 24 dc in ring, join with a sl st in top of first dc at beginning of round.

Cont in rounds with RS of work always facing.

Round 2: 5 ch, 3-trtr cluster over next 3 dc, 6 ch, *4-trtr cluster over next 4 dc, 6 ch; rep from * 4 times more, 6 ch, join with a sl st in top of first 3-trtr cluster. (6 clusters)

Round 3: 1 ch (does NOT count as a stitch), 1 dc in same place as last sl st, *[3 ch, miss next ch, 1 dc in next ch] 3 times, 3 ch, miss top of cluster, 1 dc in next ch, [3 ch, miss next ch, 1 dc in next ch] twice, 3 ch, miss next ch, 1 dc in top of next cluster; rep from * twice more,

omitting dc at end of last repeat, join with sl st in top of first dc. (Twenty-one 3-ch loops)

Round 4: 1 sl st in each of first 2 ch, 1 ch, 1 dc in same 3-ch loop, *3 ch, 1 dc in next 3-ch loop; rep from * to end, 3 ch, join with a sl st in top of first dc.

Round 5: 1 sl st in each of first 2 ch, 1 ch, 1 dc in same 3-ch loop, *5 ch, 1 dc in next 3-ch loop; rep from * to end, 5 ch, join with a sl st in top of first dc at beginning of round. (Twenty-one 5-ch loops)

Rounds 6 and 7: 1 sl st in each of first 3 ch, 1 ch, 1 dc in same 5-ch loop, *5 ch, 1 dc in next 5-ch loop; rep from * to end, 5 ch, join with a sl st in top of first dc at beginning of round.

Round 8: 1 sl st in each of first 3 ch, 1 ch, 1 dc in same 5-ch loop, *3 ch, 1 dc in next 5-ch loop; rep from * to end, 3 ch, join with a sl st in top of first dc at beginning of round. (Twenty-one 3-ch spaces) Cut off yarn, leaving a tail at least 25cm (10in) long, and fasten off. Finish as explained on page 99.

KEY

• = slip stitch

⊘ = chain stitch

+ = double crochet

 = 3-trtr cluster

 = 4-trtr cluster

7

6

5

4

3

2

1

KEY

• = slip stitch

◯ = chain stitch

† = treble cluster

| = double treble

NOTE: Work Round 8 as for Round 7.

TO MAKE THE WAGON WHEEL COVER

Note: Follow these instructions for a large pebble 10cm (4in) in diameter. For smaller pebbles, work fewer chain-loop rounds.

Base ring: Using a 2.5mm (US size C/2) hook and C, make 10 ch and join with a sl st in first ch to form a ring.

Round 1 (RS): 7 ch (counts as 1 dtr and a 3-ch space), [1dtr in ring, 3 ch] 9 times, join with a sl st in 4th of 7-ch at beginning of round. (Ten 3-ch spaces)

Cont in rounds with RS of work always facing.

Round 2: 3 ch (counts as 1 tr), *4 tr in next 3-ch space, 1 tr in top of next dtr; rep from * 8 times more, 4 tr in last 3-ch space, join with a sl st in top of 3-ch at beginning of round.

Round 3: 6 ch (counts as 1 tr and a 3-ch space), 1 tr in space between 2nd and 3rd tr of next 4-tr group, *3 ch, miss next 2 tr, 1 tr in next tr (tr worked into dtr of round 1), 3 ch, 1 tr in space between 2nd and 3rd tr of next 4-tr group; rep from * 8 times more, 3 ch, join with a sl st in 3rd of first 6-ch at beginning of round. (Twenty 3-ch spaces)

Round 4: *7 ch, 1 sl st to top of next tr; rep from * to end, working sl st of last repeat at base of first 7-ch at beginning of round.

Round 5: 1 sl st in each of first 4 ch of first 7-ch loop, * 5 ch, 1 sl st in centre ch of next 7-ch loop; rep from * to end, working sl st of last repeat at base of first 5-ch at beginning of round.

Round 6: 1 sl st in each of first 3 ch of first 5-ch loop, *3 ch, 1 sl st in centre ch of next 5-ch loop, rep from * to end, working sl st of last repeat at base of first 3-ch at beginning of round.

Rounds 7 and 8: 1 sl st in each of first 2 ch of first 3-ch space, *3 ch, 1 sl st in centre ch of next 3-ch space, rep from * to end, working sl st of last repeat at base of first 3-ch at beginning of round.

Cut off yarn, leaving a long tail, approximately 25cm (10in) long, and fasten off.

TO FINISH THE COVERS

With right side of crochet facing outwards, wrap crochet circle around large pebble. Then, using a blunt-ended yarn needle and yarn tail, insert needle from front to back through centre of each chain space of last round, one at a time (**1**). Pull yarn tail gently to gather the crochet until it is snugly and neatly stretched around the pebble (**2**). Thread yarn tail through the loops a second time, then secure (**3**).

Sew in any loose yarn ends.

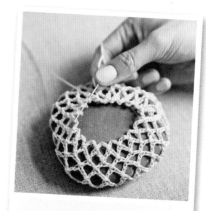

1 Weave yarn through chain spaces.

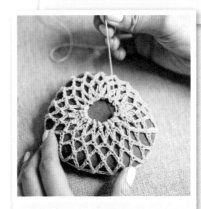

2 Pull yarn tail to gather crochet.

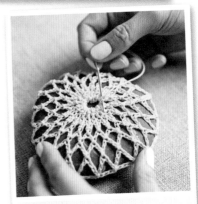

3 Secure the yarn.

Gifts and decorations

- Daisy chain • Bunny toy
- Star garland • Snowflakes
- Love heart

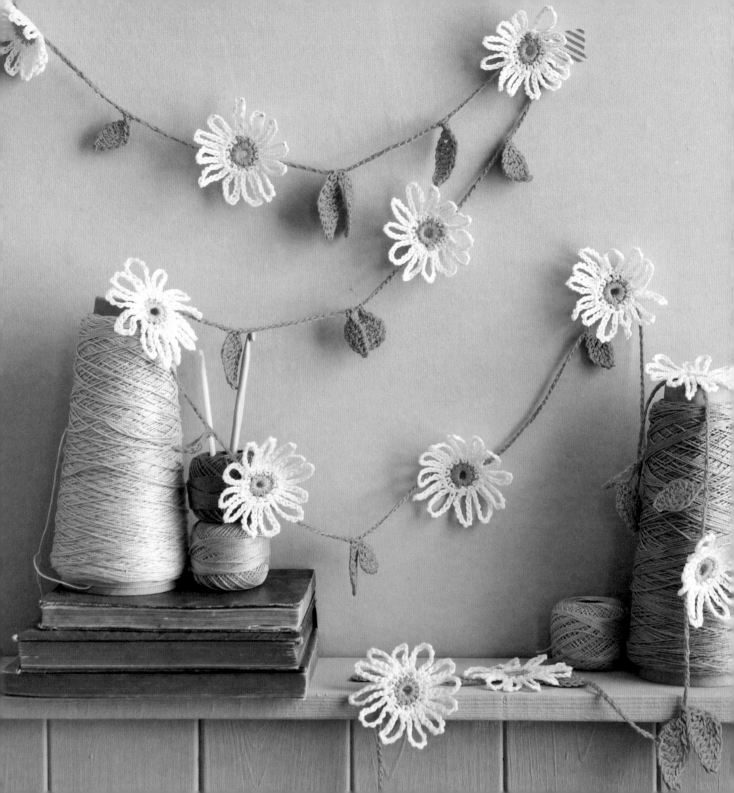

Daisy chain

Bring the freshness of a summer meadow into your home with this everlasting daisy chain. You can make the garland chain as long as you care to, and even use up oddments of mercerised cotton yarn to create a kaleidoscope of coloured flowers.

TO MAKE THE DAISIES (MAKE 12)

Base ring: Using a 2.5mm (US size C/2) hook and A, make 6 ch and join with a sl st in first ch to form a ring.

Round 1 (RS): 1 ch (does NOT count as a stitch), 12 dc in ring, change to B and join with a sl st in first dc at beginning of round. (12 dc)

Cut off A and continue with B.

Round 2 (RS): 1 ch, 1 dc in same place as last sl st, 12 ch, 1 sl st in dc just made, *1 dc in next dc of Round 1, 12 ch, 1 sl st in dc just made; rep from * 10 times more, join with a sl st in first dc at beginning of round. (12 petals) Fasten off.

TO MAKE THE LEAVES AND CHAIN

Foundation chain: Using a 2.5mm (US size C/2) hook and C, make 10 ch.

Starting with the 10-ch foundation chain, continue along chain working leaves and chain alternately as follows:

Leaf 1: 1 dc in 2nd ch from hook, 1 tr in next ch, 1 dtr in next ch, 1 trtr in each of next 2 ch, 1 dtr in next ch, 1 tr in next ch, 1 dc in next ch, 1 sl st in last ch.

**Make 37 ch.

Leaf 2: Repeat Leaf 1.

Make 46 ch.

Leaf 3: 1 dc in 2nd ch from hook, 1 tr in each of next 2 ch, 1 dtr in each of next 2 ch, 1 trtr in each of next 2 ch, 1 dtr in next ch, 1 tr in next ch, 1 dc in next ch.

Make 27 ch.

Leaves 4 and 5: Repeat Leaf 3; make 11 ch; then repeat Leaf 3 again (making one leaf either side of chain).***

Leaves 6, 7, 8 and 9: Repeat from ** to *** once more.

Make 37 ch.

SUPPLIES

CROCHET HOOK:
2.5mm (US size C/2) crochet hook

YARNS:
Yeoman Yarns *Cannele 4-ply*, or a similar super-fine-weight mercerised cotton yarn, in 3 colours:
 A Small amount in bright yellow
 B Small amount in white
 C Small amount in bright green

TENSION:
Each daisy motif measures 7cm (2¾in) in diameter using a 2.5mm (US size C/2) hook.

SIZE:
Daisy chain measures approximately 234cm (92in) long

ABBREVIATIONS:
See inside back-cover flap.

YARN NOTE:
The daisy chain weighs approximately 28g (1oz) in total, so only small amounts of yarn are required.

Leaf 10: 1 dc in 2nd ch from hook, 1 tr in next ch, 1 dtr in next ch, 1 trtr in next ch, 1 dtr in next ch, 1 tr in next ch, 1 dc in next ch, 1 sl st in next ch.
Make 56 ch.
Leaves 11 and 12: Repeat Leaf 10; make 11 ch; 1 dc in 2nd ch from hook, 1 tr in next ch, 1 dtr in each of next 2 ch, 1 trtr in next ch, 1 dtr in each of next 2 ch, 1 tr in next ch, 1 dc in next ch, 1 sl st in next ch. ****
Leaves 13–19: Repeat from *** to **** once.
Leaves 20–23: Repeat from ** to *** once.
Make 37 ch.
Leaf 24: Repeat Leaf 1.
Fasten off.

TO FINISH

Pin the daisies along the chain between the leaves, judging the spacing by eye.
Using a single strand of A (or a matching sewing thread) and a sewing needle, catch stitch the back of each daisy at its centre, for approximately 1 cm (³⁄₈in), to the chain.
Sew in any loose yarn ends.

Work each leaf with basic stitches

Work the stems with simple chains.

KEY

• = slip stitch

◯ = chain stitch

+ = double crochet

| = treble crochet

= double treble

= triple treble

LEAF 1

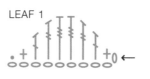

LEAF 10

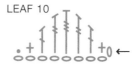

LEAF 3

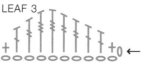

LEAF 12

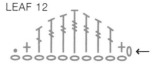

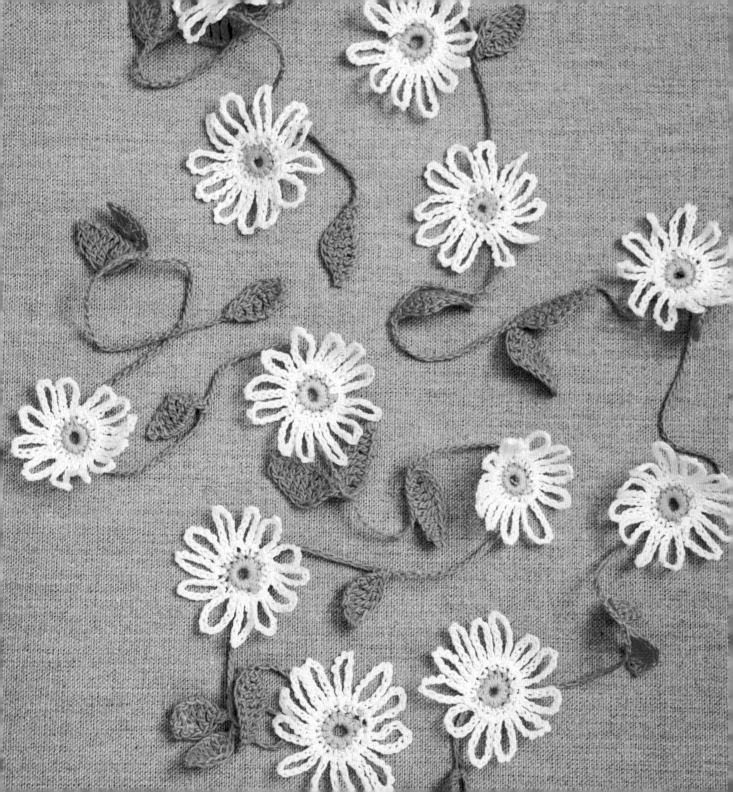

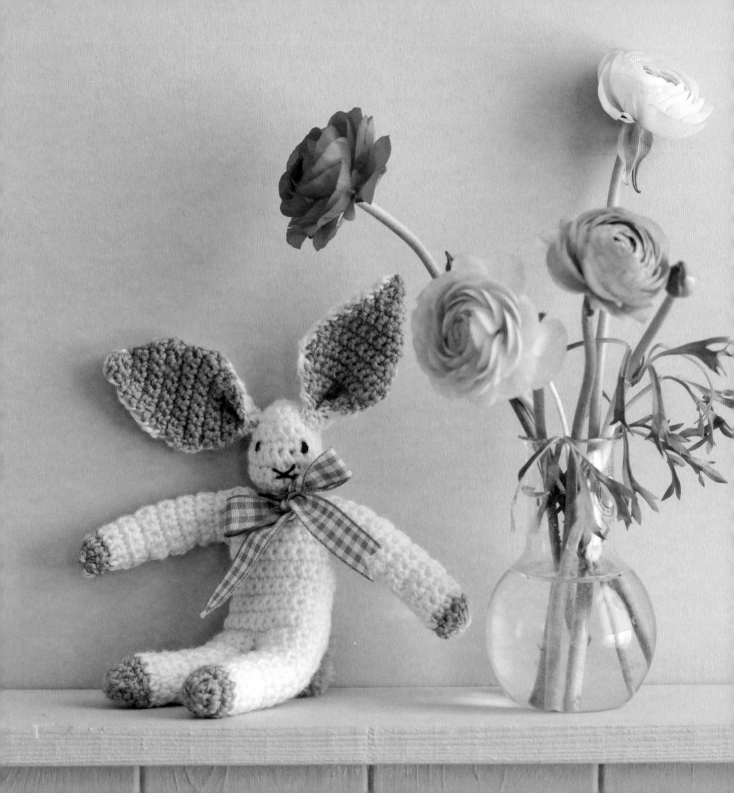

Bunny toy

This bob-tail bunny is the perfect pocket-size pal, so you've no excuse to ever be without your very own lucky rabbit mascot. Crocheted in a cuddly super-fine wool yarn, it would look even cuter on the shelf with a partner in a different colour.

TO MAKE THE ARMS (MAKE 2)

Foundation chain: Using a 3mm (US size D/3) hook and MC, make 11 ch, leaving a long loose yarn end.
Row 1: 1 dc in 2nd ch from hook, 1 dc in each of remaining ch, turn. (10 dc)
Row 2: 1 ch (does NOT count as a stitch), 1 dc in each dc to end of row, turn.
Rows 3–15: [Rep Row 2] 13 times.
Rows 16 and 17: Change to CC and [rep Row 2] twice.
Fasten off, leaving a long loose yarn end.

TO MAKE THE LEGS AND BODY

The two legs are worked separately first, then they are joined together across the top to work the body.
First leg
Foundation chain: Using a 3mm (US size D/3) hook and CC, make 13 ch, leaving a long loose yarn end.

Row 1 (RS): 1 dc in 2nd ch from hook, 1 dc in each of remaining ch, turn. (12 dc)
Rows 2 and 3: 1 ch (does NOT count as a stitch), 1 dc in each dc to end of row, turn.
Row 4: Change to MC and rep Row 2.
Row 5–15: Using MC, [rep Row 2] 11 times.
Fasten off and set aside.
Second leg
Work foundation chain and Rows 1–15 as for First Leg, but do not fasten off.
Join legs and work body
Row 16 (WS): 1 ch, 1 dc in each dc to end of row of Second Leg, then with WS of First Leg facing, work 1 dc in each dc to end, turn. (24 dc)
Row 17: 1 ch (does NOT count as a stitch), 1 dc in each dc to end of row, turn. (24 dc)
Rows 18–32: [Rep Row 17] 15 times.
Fasten off.

SUPPLIES

CROCHET HOOK:
3mm (US size D/3) crochet hook

YARNS:
Debbie Bliss Yarns *Rialto 4-ply*, or a similar super-fine-weight wool yarn, in 2 colours:
 MC 1 x 50g (1¾oz) ball in ecru
 CC 1 x 50g (1¾oz) ball in dusty pink

EXTRAS:
Safety toy stuffing
Black cotton embroidery thread
36cm (14¼in) of gingham ribbon, 1.5cm (⅝in) wide

TENSION:
24 sts and 24 rows to 10cm (4in) measured over double crochet using a 3mm (US size D/3) hook.

SIZE:
Finished toy is approximately 22cm (8¾in) tall, including ears

ABBREVIATIONS:
See inside back-cover flap.

TO MAKE THE HEAD

Base ring: Using MC, wind yarn twice around a finger to form a ring of yarn, then remove and, using a 3mm (US size D/3) hook, work in rounds as follows:

Round 1 (RS): 1 sl st in ring, 1 ch (does NOT count as a stitch), 5 dc in ring, then pull loose yarn end to tighten circle and join with a sl st in top of first dc. (5 dc)

Continue in rounds with RS always facing.

Round 2: 1 ch, 2 dc in same place as last sl st, [2 dc in next dc] 4 times, join with a sl st in top of first dc. (10 dc)

Round 3: 1 ch, 1 dc in same place as last sl st, 2 dc in next dc, *1 dc in next dc, 2 dc in next dc; rep from * to end, join with a sl st in top of first dc. (15 dc)

Round 4: 1 ch, 1 dc in same place as last sl st, *1 dc in next dc; rep from * to end of round, join with a sl st in top of first dc.

Round 5: Rep Round 4.

Round 6: 1 ch, 2 dc in same place as last sl st, 1 dc in each of first 4 dc, *2 dc in next dc, 1 dc in each of next 4 dc; rep from * once more, join with a sl st in top of first dc. (18 dc)

Rounds 7, 8 and 9: [Rep Round 4] 3 times.

Round 10: 1 ch, 1 dc in same place as last sl st, 1 dc in each of next 4 dc, miss next dc, [1 dc in each of next 5 dc, miss next dc] twice, join with a sl st in top of first dc. (15 dc)

Round 11: 1 ch, 1 dc in same place as last sl st, 1 dc in each of next 3 dc, miss next dc, [1 dc in each of next 4 dc, miss next dc] twice, join with a sl st in top of first dc. (12 dc)

Round 12: 1 ch, 1 dc in same place as last sl st, 1 dc in each of next 2 dc, miss next dc, [1 dc in each of next 3 dc, miss next dc] twice, join with a sl st in top of first dc. (9 dc)

Fasten off, leaving a long loose yarn end.

TO MAKE THE OUTER EARS (MAKE 2)

Foundation chain: Using a 3mm (US size D/3) hook and MC, make 5 ch.

Row 1: 1 dc in 2nd ch from hook, 1 dc in each of remaining ch, turn. (4 dc)

Row 2: 1 ch (does NOT count as a ch), 2 dc in first dc, 1 dc in each of next 2 dc, 2 dc in last dc, turn. (6 dc)

Row 3: 1 ch, 1 dc in each dc to end of row, turn.

Row 4: 1 ch, 2 dc in first, 1 dc in each dc to last dc, 2 dc in last dc, turn. (8 dc)

Rows 5 and 6: [Rep Row 3] twice.

Row 7: Rep Row 4. (10 dc)

Rows 8 and 9: [Rep Row 3] twice.

Row 10: 1 ch, 1 dc in first dc, miss next dc, 1 dc in each of next 6 dc, miss next dc, 1 dc in last dc, turn. (8 dc)

Rows 11, 12 and 13: [Rep Row 3] 3 times.

Row 14: 1 ch, 1 dc in first dc, miss next dc, 1 dc in each of next 4 dc, miss next dc, 1 dc in last dc, turn. (6 dc)

Row 15: Rep Row 3.

Row 16: 1 ch, 1 dc in first dc, miss next dc, 1 dc in each of next 2 dc, miss next dc, 1 dc in last dc, turn. (4 dc)

Row 17: 1 ch, miss first dc, 1 dc in each of next 3 dc, turn. (3 dc)

Row 18: 1 ch, miss first dc, 1 dc in each of next 2 dc, turn. (2 dc)

Row 19: 1 ch, miss first dc, 1 dc in next dc. (1 dc)

Fasten off.

TO MAKE THE INNER EARS (MAKE 2)

Using a 3mm (US size D/3) hook and CC, make two in exactly same way as Outer Ears.

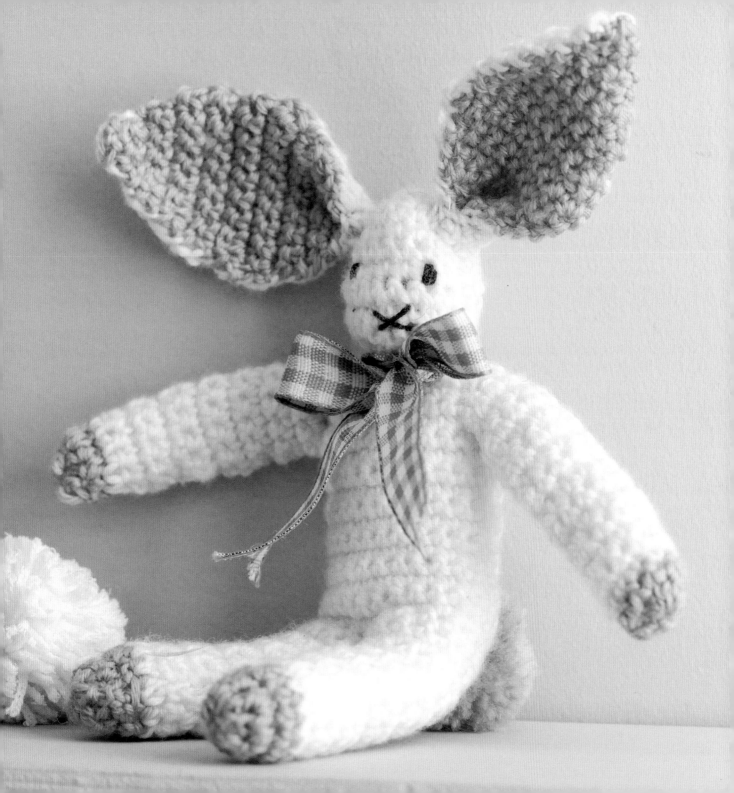

TO FINISH

With wrong sides together, place an Inner Ear on top of an Outer Ear and sew neatly together all around the edge. Then fold the ear in half lengthwise at the foundation-chain edge, with the Inner Ear inside, and sew together along the foundation-chain edge.

Using the long loose yarn end in CC at the end of each leg and a blunt-ended yarn needle, weave the yarn end through the foundation-chain edge stitches, pull to gather the stitches together and secure.

Fold the Legs in half lengthwise and sew the inner leg seams, then sew the centre back seam of the Body. Fill the Legs and Body firmly with toy stuffing.

Gather the ends of the Arms as for the Legs and sew the arm seams. Fill the Arms with toy stuffing.

Fill the Head firmly with toy stuffing, then neatly sew the neck edge to the Body, stitching around both front and back and leaving a shoulder at either side. Sew shoulder seams.

Sew one ear to each side of the Head, approximately 1cm (³⁄₈in) from the centre of the top of the head. Using black cotton embroidery thread, embroider the face, working satin-stitch eyes, and a sideways cross for the mouth and nose.

Sew in any loose yarn ends.

Trim a V-shape out of each end of the ribbon and tie it in a bow around the rabbit's neck.

Add pompom tail following the step-by-step instructions below.

IF THE BUNNY TAIL DOESN'T LOOK THIS ROUND, TRIM IT NEATLY INTO SHAPE.

MINI-POMPOM TAIL

Using CC, make one mini pompom 3–3.5cm (1¼–1³⁄₈in) in diameter as follows:

Using a kitchen fork to make the pompoms, first cut a length of yarn approximately 40cm (16in) long and slip it between the centre of the fork prongs, leaving it to hang there (**1**) – this is the tying strand. Next, wrap yarn from the ball in a figure of eight a few times around the prongs to hold it in place (**2**). Then wrap the yarn around the outer prongs until it is nice and thick (**3**). Using the strand at the centre of the fork, tie the wrapped yarn together at the centre (**4**) and gently slip the yarn off the fork (**5**); pull the tying strand tightly and knot. Carefully cut the loops (**6**) – some may be hidden so be sure to cut them all. Being careful not to cut the tying strand, trim any straggly ends on your pompom so that it is neat and round.

Using the tying strands, sew the tail securely to the back of the bunny, just above the legs.

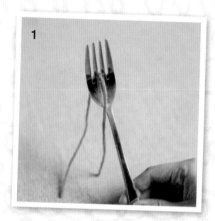

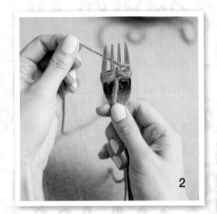

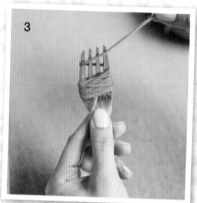

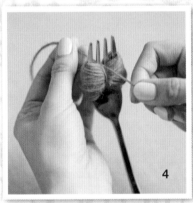

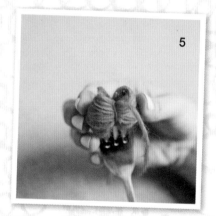

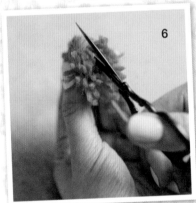

Star garland

These eight-pointed star motifs create a beautiful decorative garland. I've used colours inspired by the paintings of the Bloomsbury set, but feel free to use up any leftovers from other projects to make your own stars.

CROCHET HOOKS:
2mm and 2.5mm (US sizes B/1 and C/2) crochet hooks

YARNS:
Yeoman Yarns *Cannele 4-ply*, or a similar super-fine-weight mercerised cotton yarn, in 7 colours
A Small amount in linen
B Small amount in pale mustard
C Small amount in coral
D Small amount in light sage green
E Small amount in terracotta
F Small amount in dusky lilac
G Small amount in burgundy

EXTRAS:
Spray starch (optional)

TENSION:
Each star motif measures approximately 9cm (3½in) in diameter using a 2.5mm (US size C/2) hook.

SIZE:
Garland measures approximately 200cm (78¾in) long (unstretched)

ABBREVIATIONS:
See inside back-cover flap.

YARN NOTE:
Each star motif requires approximately 5g (¼oz) of yarn – or 18m (20yd).

TO MAKE THE STAR MOTIFS (MAKE 15)

Base ring: Using a 2.5mm (US size C/2) hook and A, make 5 ch and join with a sl st in first ch to form a ring.

Round 1 (RS): 7 ch (counts as 1 dtr and a 3-ch space), [1 dtr in ring, 3 ch] 7 times, join with a sl st in 4th of 7-ch at beginning of round. (8 spaces)
Continue in rounds with RS of work always facing.

Round 2: 3 ch (counts as 1 tr), [4 tr in next 3-ch space, 1 tr in next dtr] 7 times, 4 tr in last 3-ch space, join with a sl st in top of 3-ch at beginning of round. (40 sts)

Round 3: 1 ch, 1 dc in same place as last sl st, *6 ch, 1 dc in 2nd ch from hook, 1 htr in next ch, 1 tr in next ch, 1 dtr in next ch, 1 trtr in next ch, miss 4 tr, 1 dc in next st; rep from * 7 times more, omitting 1 dc at end of last repeat, join with a sl st in top of first dc at beginning of round. (8 points)
Fasten off and weave in any loose yarn ends.

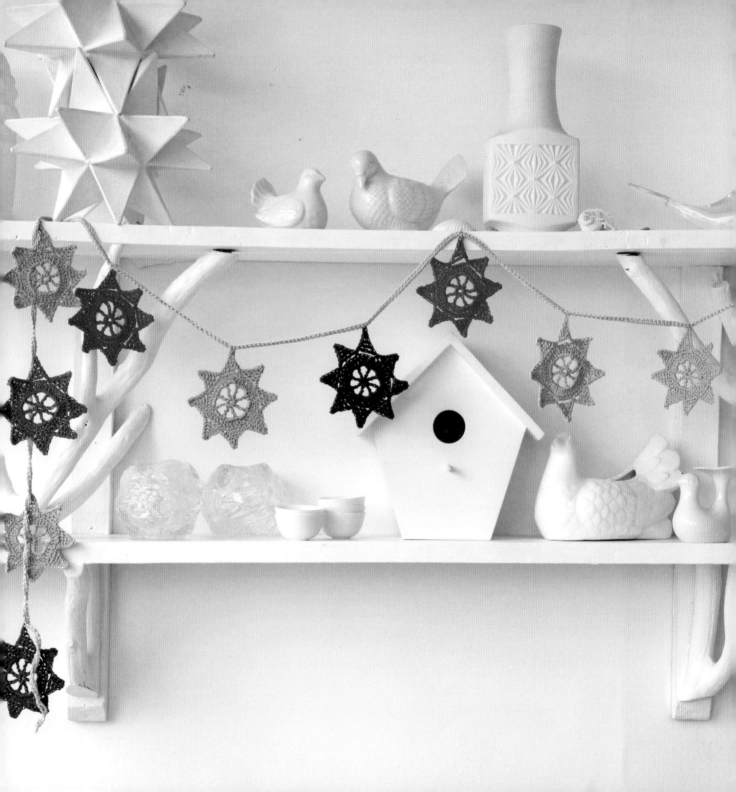

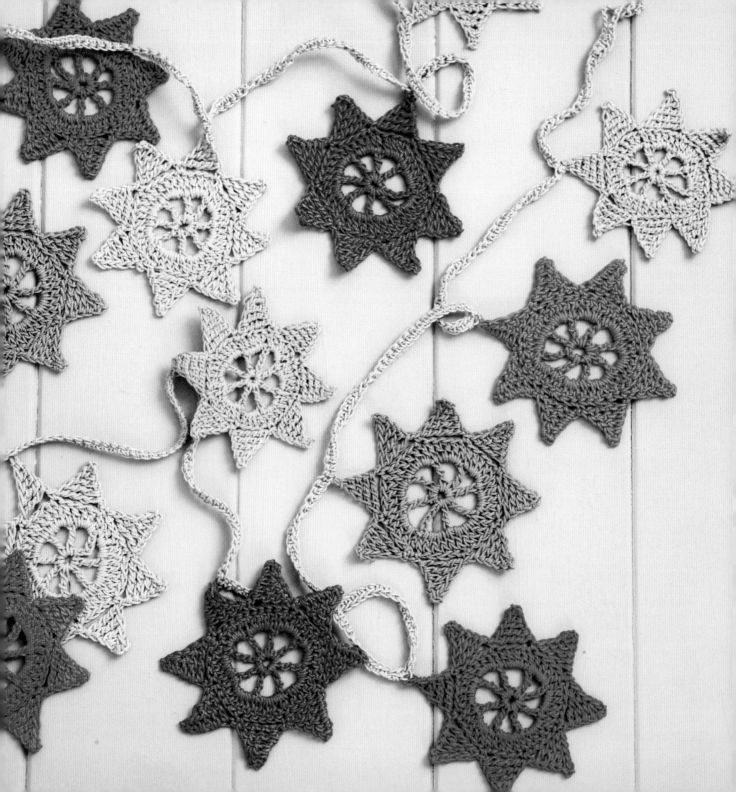

Make a total of 15 star motifs in the same way – 1 more in A, 3 in B, and 2 each in C, D, E, F and G.

TO MAKE THE GARLAND CORD

Row 1 (RS): Using a 2mm (US size B/1) hook and A, make 20 ch, 1 sl st in first chain to form a loop for hanging, 22 ch, *with right side of a star facing, join star onto chain with a sl st in top of one point, 30 ch; rep from * until all the 15 stars are joined onto chain, 42 ch, 1 sl st in 20th chain from hook to form second hanging loop, turn.
Row 2: 1 dc in first free ch after hanging loop, 1 dc in each ch to 1 ch before beginning of hanging loop at opposite end, 1 sl st in last free ch.
Fasten off.

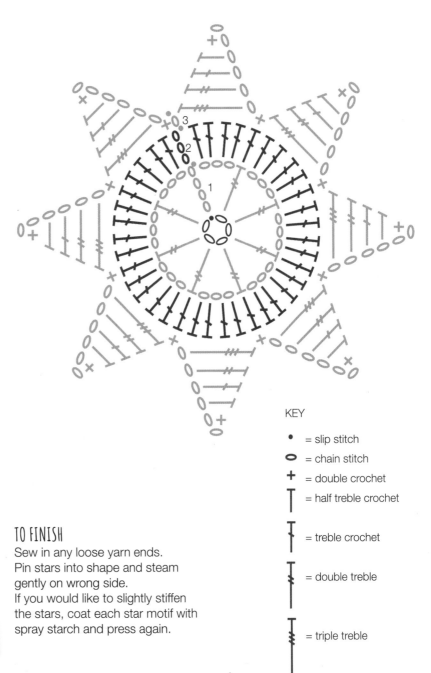

Catch the stars into the first row of the garland cord.

TO FINISH

Sew in any loose yarn ends.
Pin stars into shape and steam gently on wrong side.
If you would like to slightly stiffen the stars, coat each star motif with spray starch and press again.

KEY

• = slip stitch

○ = chain stitch

+ = double crochet

⊤ = half treble crochet

┊ = treble crochet

┊ = double treble

┊ = triple treble

Snowflakes

Delicate crocheted snowflakes in ice white crisp cotton make a spectacular seasonal display when hung from natural branches. As in nature, each one of these snowflakes has its own unique design. They are starched to hold their perfect shapes.

ABBREVIATIONS:
2-tr cluster: [Yrh and insert hook in next st, yrh and draw a loop through, yrh and draw through first 2 loops on hook] twice, yrh and draw through all 3 loops on hook.
qtr (quadruple treble): Yrh 4 times and insert hook in st, yrh and draw a loop through, [yrh and draw through first 2 loops on hook] 5 times to complete qtr.
quintr (quintuple treble): Yrh 5 times and insert hook in st, yrh and draw a loop through, [yrh and draw through first 2 loops on hook] 6 times to complete quintr.
See also inside back-cover flap.

YARN NOTE:
To make one snowflake, you will need only approximately 8g (¼oz) of yarn – or 28m (30½yd). For all five snowflakes, you will need 40g (1⅜oz) of yarn – or 140m (153yd).

TO MAKE THE ICICLE SNOWFLAKE

Note: See page 118 for stitch diagram.
Base ring: Using a 2mm (US size B/1) hook, make 5 ch and join with a sl st in first ch to form a ring.
Round 1 (RS): 1 ch (does NOT count as a stitch), 10 dc in ring, join with a slip stitch in top of first dc at beginning of round. Continue in rounds with RS of work always facing.
Round 2: 1 ch, 1 dc in same place as last slip stitch, 3 ch, *1 dc in next dc, 3 ch; rep from * end, join with a sl st in top of first dc at beginning of round. (Ten 3-ch loops)
Round 3: *14 ch, 1 slip stitch in 4th ch from hook, 10 ch, 1 sl st in next dc (this completes short point), 10 ch, 1 sl st in 6th ch from hook, [8 ch, 1 sl st in 6th ch from hook] twice, 10 ch, 1 sl st in 8th ch from hook, [8 ch, 1 sl st in 6th ch from hook] 3 times, 4 ch, 1 sl st in next dc (this completes long picot point); rep from * 4 times more, working last sl st of last repeat in top of first dc of previous round. (10 points) Fasten off.

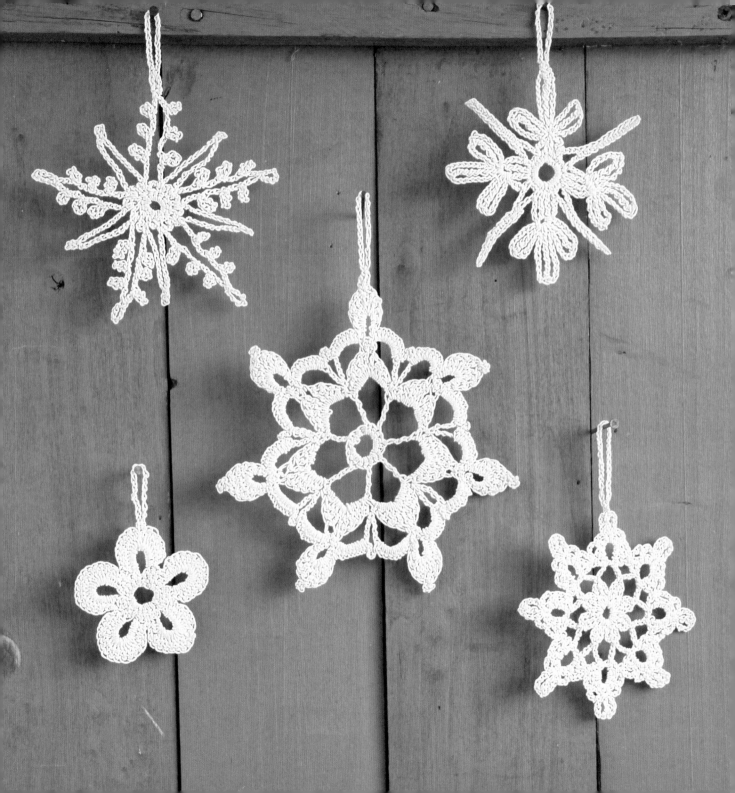

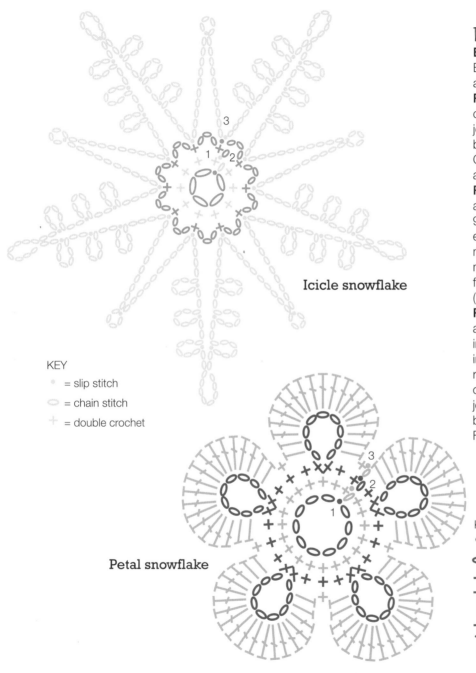

Icicle snowflake

TO MAKE THE PETAL SNOWFLAKE

Base ring: Using a 2mm (US size B/1) hook, make 10 ch and join with a sl st in first ch to form a ring.

Round 1 (RS): 1 ch (does NOT count as a stitch), 20 dc in ring, join with a sl st in top of first dc at beginning of round. (20 sts) Continue in rounds with RS of work always facing.

Round 2: 1 ch, 1 dc in same place as last sl st, 1 dc in next dc, *[1 dc, 9 ch, 1 dc] all in next dc **, 1 dc in each of next 3 dc; rep from * 3 times more and from * to ** once, 1 dc in next dc, join with a sl st in top of first dc at beginning of round. (Five 9-ch loops)

Round 3: 1 ch, 1 dc in same place as last sl st, *[2 htr, 15 tr, 2 htr] all in next 9-ch loop, miss 2 dc, 1 dc in next dc (centre dc of 3-dc group); rep from * 4 times more, but omitting dc at end of last repeat, join with a sl st to top of first dc at beginning of round. Fasten off.

KEY

• = slip stitch

◯ = chain stitch

✛ = double crochet

Petal snowflake

KEY

• = slip stitch

◯ = chain stitch

✛ = double crochet

⊤ = half treble crochet

⊤ = treble crochet

TO MAKE THE MOTIF SNOWFLAKE

Base ring: Using a 2mm (US size B/1) hook, make 8 ch and join with a sl st in first ch to form a ring.

Round 1 (RS): 1 ch (does NOT count as a stitch), 14 dc in ring, join with a sl st in top of first dc at beginning of round. (14 sts) Continue in rounds with RS of work always facing.

Round 2: 12 ch (counts as 1 dtr and an 8-ch loop), miss next dc, [1 dtr in next dc, 8 ch, miss 1 dc] 6 times, join with a sl st in 4th of 12-ch at beginning of round. (Seven 8-ch loops)

Round 3: 1 ch (does NOT count as a stitch), *work [1 dc, 1 htr, 1 tr, 3 dtr, 4 ch, 1 sl st in top of dtr just made, 2 dtr, 1 tr, 1 htr, 1 dc] all in next 8-ch loop; rep from * 6 times more, join with a sl st in first dc at beginning of round.

Round 4: *10 ch, 1 sl st in same place as base of next 4-ch loop, 10 ch, 1 sl st in opposite side of base of same 4-ch loop, 10 ch, 1 sl st in space between next 2 dc; rep from * 6 times more.

Round 5: 1 sl st in each of next 5 ch, *10 dc in remaining 5-ch loop, work [1dc, 1 htr, 1 tr, 3 dtr, 4 ch, 1 sl st in 4th ch from hook, 2 dtr, 1 tr, 1 htr, 1 dc] in next 10-ch loop, 10 dc in next 10-ch loop, 1 sl st in 5th ch of same 10-ch loop, 4 ch, 1 sl st in 5th ch of next 10-ch loop; rep from * 6 times more.
Fasten off.

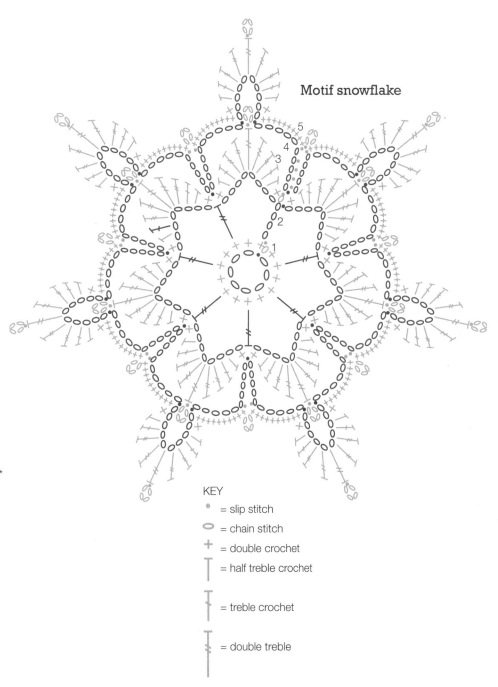

Motif snowflake

KEY
- • = slip stitch
- ◯ = chain stitch
- + = double crochet
- ⊤ = half treble crochet
- ⊤ = treble crochet
- ⊤ = double treble

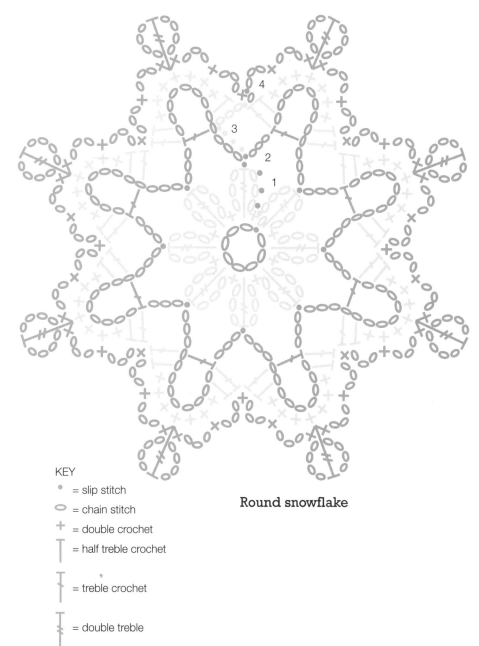

Round snowflake

KEY

- = slip stitch
- = chain stitch
+ = double crochet
⊤ = half treble crochet
† = treble crochet
‡ = double treble

TO MAKE THE ROUND SNOWFLAKE

Base ring: Using a 2mm (US size B/1) hook, make 8 ch and join with a sl st in first ch to form a ring.

Round 1 (RS): 1 ch (does NOT count as a stitch), [1 dc in ring, 3 ch, 1 dtr in ring, 3 ch] 8 times, join with a sl st in top of first dc at beginning of round.

Continue in rounds with RS of work always facing.

Round 2: 1 sl st in each of next 3 ch, 1 sl st in first dtr, [12 ch, 1 tr in 9th ch from hook, 3 ch, 1 sl st in top of next dtr] 8 times. (8 points)

Round 3: 1 sl st into each next 4 ch, 3 ch (counts as first tr), *[1 htr, 7 dc, 1 htr] in next 8-ch loop, 1 tr in next tr, miss last 3-ch of this point and first 3-ch of following point, 1 tr in next ch; rep from * 6 times more, 1 htr, 7 dc, 1 htr, in last 8-ch loop, 1 tr in next tr, miss last 3-ch of this point and first 3-ch of following point, join with a sl st in top of 3-ch at beginning of round.

Round 4: 1 ch, 1 dc in same place as last sl st (inserting hook under this sl st that joined 3rd round), *3 ch, miss [1 htr, 1 dc], 1 dc in next dc, 3 ch, miss 1 dc, [1 dc, 4 ch, 1 dtr, 4 ch, 1 dc] in next dc, 3 ch, miss 1 dc, 1 dc in next dc, 3 ch, miss [1 dc, 1 htr, 1 tr], 1 dc in space between (and below) the 2 tr, miss 1 tr; rep from * 7 times more omitting 1 dc at end of last repeat, join with a sl st in top of first dc at beginning of round.
Fasten off.

TO MAKE THE STAR SNOWFLAKE

Base ring: Using a 2mm (US size B/1) hook, make 8 ch and join with a sl st in first ch to form a ring.

Round 1 (RS): 1 ch (does NOT count as a stitch), 24 dc in ring, join with a sl st in top of first dc at beginning of round. (24 sts) Continue in rounds with RS of work facing.

Round 2: 1 ch, 1 dc in same place as last sl st, *4 ch, 2-tr cluster over next 2 dc, then working into the top of st (2-tr cluster) just made, work a set of 3 looped groups as follows – [7 ch, 1 qtr, 7 ch, 1 dc, 8 ch, 1 quintr, 8 ch, 1 dc, 7 ch, 1 qtr, 7 ch, 1 sl st] all in top of 2-tr cluster, 4 ch, 1 dc in next dc of first round, 14 ch, 1 dc in 2nd ch from hook, 1 dc in each of next 9 ch, 3 ch, miss 2 dc of first round, 1 dc in next dc; repeat from * 3 times more, omitting dc at end of last repeat, join with a sl st in top of first dc at beginning of round.
Fasten off.

TO FINISH THE SNOWFLAKES

Sew in any loose yarn ends. Pin snowflakes into shape and steam gently on wrong side. Then coat each snowflakes with spray starch or sugar water and press to stiffen.

Hanging loop

Using a 2mm (US size B/1) hook, join yarn with a sl st to the tip of one of the points (or to the centre of one of the petals), then make 20 ch (or more for a longer loop), join with a sl st to first ch to make a loop. Fasten off and sew in yarn ends.

KEY

- • = slip stitch
- ⭕ = chain stitch
- + = double crochet

= 2-tr cluster

= quadruple treble

= quintuple treble

Star snowflake

Love heart

Worked in a matt cotton yarn in double crochet, this heart is a great project for a beginner. For the increases to form the shape, you simply work two double crochet into the one below – and for decreases, you just miss a stitch. The perfect gift for a loved one.

SUPPLIES

CROCHET HOOK:
3mm (US size D/3) crochet hook

YARN:
Yeoman Yarns *DK Soft Cotton*, or a similar lightweight matt cotton yarn, in one colour:
 Small amount in red

EXTRAS:
Safety toy stuffing

TENSION:
16 sts and 18 rows to 10cm (4in) measured over double crochet using a 3mm (US size D/3) hook.

SIZE:
Finished stuffed heart measures approximately 13.5cm (5¼in) wide x 13cm (5in) tall

ABBREVIATIONS:
See inside back-cover flap.

YARN NOTE:
The heart requires approximately 15g (½oz) of yarn – or about 30m (33yd).

TO MAKE THE HEART (MAKE 2)

Foundation chain: Using a 3mm (US size D/3) hook, make 2 ch.
Row 1 (RS): 1 dc in 2nd ch from hook, turn. (1 dc)
Row 2: 1 ch (does NOT count as a stitch), 3 dc in dc, turn. (3 dc)
Row 3: 1 ch, 2 dc in first dc, 1 dc in next dc, 2 dc in last dc, turn. (5 dc)
Row 4: 1 ch, 2dc in first dc, 1 dc in each of next 3 dc, 2 dc in last dc, turn. (7 dc)
Row 5: 1 ch, 2 dc in first dc, 1 dc in each of next 5 dc, 2 dc in last dc, turn. (9 dc)
Row 6: 1 ch, 2 dc in first dc, 1 dc in each of next 7 dc, 2 dc in last dc, turn. (11 dc)
Row 7: 1 ch, 2 dc in first dc, 1 dc in each of next 9 dc, 2 dc in last dc, turn. (13 dc)
Row 8: 1 ch, 1 dc in each of first 6 dc, 2 dc in next dc, 1 dc in each of last 6 dc, turn. (14 dc)
Rows 9 and 10: 1 ch, 1 dc in each dc to end of row, turn. (14 dc)
Row 11: 1 ch, 1 dc in each of first 6 dc, 2 dc in next dc, 1 dc in each of last 7 dc, turn. (15 dc)
Row 12: 1 ch, 1 dc in each dc to end of row, turn. (15 dc)
Row 13: 1 ch, 1 dc in each of first 7 dc, 2 dc in next dc, 1 dc in each of last 7 dc, turn. (16 dc)
Row 14: 1 ch, 1 dc in each dc to end of row, turn. (16 dc)
Row 15: 1 ch, 2 dc in first dc, 1 dc in each of next 14 dc, 2 dc in last dc, turn. (18 dc)
Row 16: 1 ch, 1 dc in each of first 8 dc, 2 dc in next dc, 1 dc in each of last 9 dc, turn. (19 dc)
Row 17: 1 ch, 2 dc in first dc, 1 dc in each dc to end of row, turn. (20 dc)
Row 18: Rep Row 17. (21 dc)
Row 19: Rep Row 17. (22 dc)
Row 20: Rep Row 17. (23 dc)
Shape first side of top of heart
Row 21 (RS): 1 ch, 1 dc in each of first 11 dc, turn (leaving remaining 12 dc unworked).
Row 22: 1 ch, miss first dc, 1 dc in each of next 8 dc, miss next dc, 1 dc in last dc, turn. (9 dc)
Row 23: 1 ch, miss first dc, 1 dc in each of next 6 dc, miss next dc, 1 dc in last dc, turn. (7 dc)
Row 24: 1 ch, miss first dc, 1 dc in

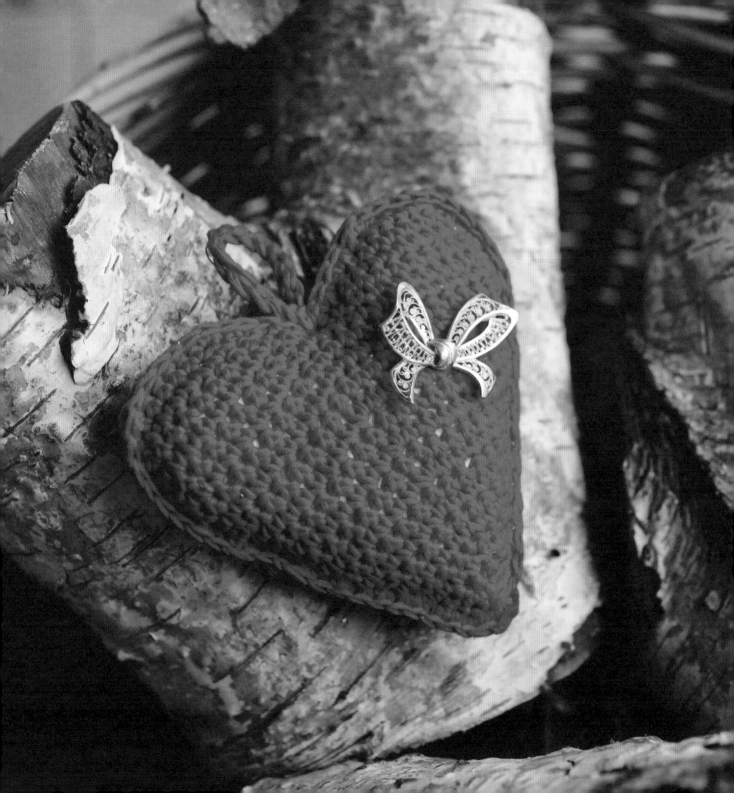

THE DOUBLE CROCHET SEAM
AROUND THE HEART GIVES IT A
NEAT RIDGED EDGE.

each of next 6 dc, turn. (6 dc)
Row 25: 1 ch, miss first dc, 1 dc in
each of next 3 dc, miss next dc,
1 dc in last dc. (4 dc)
Fasten off.
Shape second side of top of heart
With RS facing and using a 3mm
(US size D/3) hook, rejoin yarn
with a sl st in centre st of heart in
section left unworked in Row 21 and
continue as follows:
Row 21 (RS): 1 ch, miss dc with
sl st in it, 1 dc in each dc to end of
row, turn. (11 dc)
Row 22: 1 ch, miss first dc, 1 dc in
each of next 8 dc, miss next dc,

1 dc in last dc, turn. (9 dc)
Row 23: 1 ch, miss first dc, 1 dc in
each of next 6 dc, miss next dc,
1 dc in last dc, turn. (7 dc)
Row 24: 1 ch, 1 dc in each of first
5 dc, miss next dc, 1 dc in last dc,
turn. (6 dc)
Row 25: 1 ch, miss first dc, 1 dc in
each of next 3 dc, miss next dc,
1 dc in last dc. (4 dc)
Fasten off.

TO FINISH
Place hearts with right sides
together, and beginning halfway
down one side, join hearts together

with a double crochet seam around
the edge, stopping when seam is
3cm (1¼in) from the first dc.
Fill heart firmly with toy stuffing,
then complete double crochet seam
and join with a slip stitch in first dc
of round.
Fasten off.
Sew in any loose yarn ends.
Hanging chain
Using a 3mm (US size D/3) hook
and 2 strands of yarn held together,
join yarn with a sl st in centre st of
heart, make 16 chain loosely, then
join with a slip stitch in first chain.
Fasten off and sew in yarn ends.

INDEX

CHOOSING YARNS

It is always best to use the yarn recommended in the crochet pattern in order to achieve the result shown. If you decide to use a substitute yarn for any of the items in this book, find one that is similar in weight, texture and fibre content. To determine the weight (thickness) of a yarn, take into account the generic description of the weight and the manufacturer's recommended tension over knitted stocking stitch as well as the recommended knitting needle size. Tension over stocking stitch is the manufacturer's method for describing yarn thickness. Tension over stocking stitch is a more accurate way of describing a yarn weight than tension over crochet. Always calculate the amount of substitute yarn you will need by metres (yards) per ball, not by grams. The yarns recommended for the crochet projects in this book are listed below, with their specifications.

Debbie Bliss Yarns Rialto DK
A lightweight wool yarn; 100% extra-fine merino wool; 105m (115yd) per 50g (1¾oz) ball; recommended knitting tension – 22 sts and 30 rows to 10cm (4in) over st st using 4mm (US size 6) knitting needles.

Debbie Bliss Yarns Rialto 4-Ply
A super-fine-weight wool yarn; 100% extra-fine merino wool; 180m (197yd) per 50g (1¾oz) ball; recommended knitting tension – 28 sts and 38 rows to 10cm (4in) over st st using 3.25mm (US size 3) knitting needles.

Hoopla Yarn
A super-bulky-weight yarn made from approximately 1cm-wide selvedge edges from jersey (T-shirt) fabric; 95–100% cotton and 0–5% lycra; 100m (109½yd) per 500g (17⅝oz) cone; recommended hook size – 7–12mm (US sizes L/11–P); recommended knitting needle size – 10mm+ (US size 15+).

Mondial Yarns Kross Chunky
A chunky-weight wool yarn; 100% merino; 80m (88yd) per 100g (3½oz) ball; recommended knitting tension – 12 sts and 18 rows to 10cm (4in) over st st using 6.5–7.5mm (US size 10½–11) knitting needles.

Nutscene 3-ply Jute Twine
A jute garden twine; 3-ply thickness; 110m (120yd) per spool

Rowan Yarns Creative Focus Worsted
A medium-weight wool and alpaca yarn; 75% wool, 25% alpaca; 200m (220yd) per 100g (3½oz) ball; recommended knitting tension – 20 sts and 24 rows to 10cm (4in) over st st using 4.5mm (US size 7) knitting needles.

Yeoman Yarns Cannele 4-ply
A super-fine-weight cotton yarn; 100% mercerised cotton; 850m (957yd) per 245g (8¾oz) cone.

Yeoman Yarns DK Soft Cotton
A lightweight cotton yarn; 100% soft matt cotton; 900m (984yd) per 450g (15⅞oz) cone; recommended knitting needle size – 4mm (US size 6).

Yarn suppliers

Search on the internet for yarn suppliers near you, or contact the following websites:

Debbie Bliss Yarns
debbieblissonline.com

Hoopla Yarn
hooplayarn.com
hooplayarn.co.uk

Mondial Yarns
Mondial Yarns are available from Yeoman Yarns in the UK

Nutscene
nutscene.com

Rowan Yarns
knitrowan.com

Yeoman Yarns
yeoman-yarns.co.uk

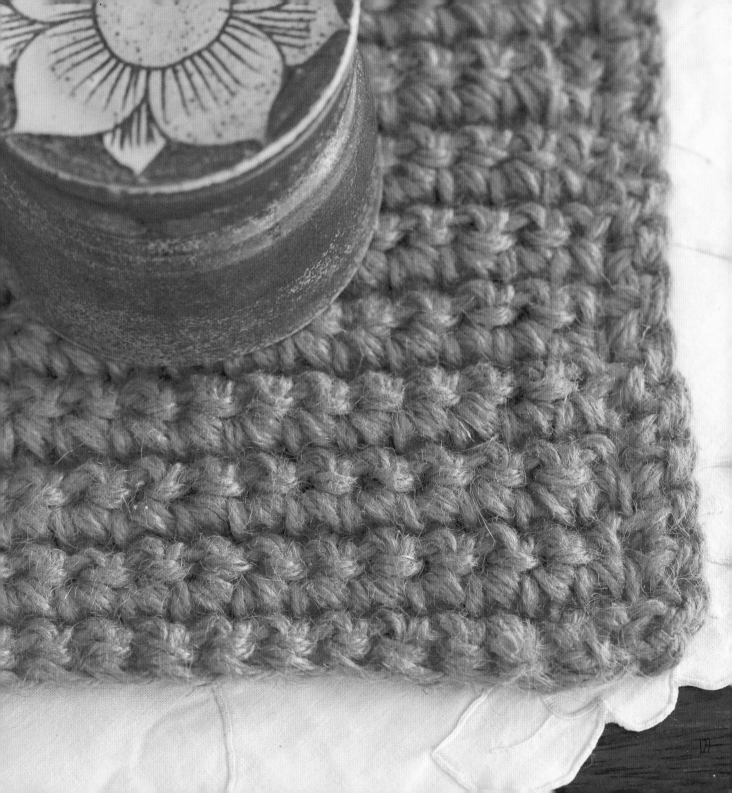

DEDICATION

To my grandmother Mary Elizabeth Hunter for teaching me to crochet, inspiring a lifelong passion.

THANK YOU THANK YOU THANK YOU

A special thank you to Lisa at Quadrille for this commission and to my agent and friend Jane Turnbull – I have wanted to do a crochet book for many years and they made it happen. Thank you to all at Quadrille too, especially designer Claire and Chinh, as well as photographer Keiko and stylist Christine for making this such a beautiful book.

Huge thanks go to Yeoman Yarn for supplying yarn for the majority of projects and to Debbie Bliss and Rowan for their contributions too. Thanks as ever to my family Ben, Martha and CeCe for believing that sitting on a sofa for three months crocheting really is work.

Publishing Director Jane O'Shea
Creative Director Helen Lewis
Commissioning Editor Lisa Pendreigh
Editor Sally Harding
Design & Art Direction Claire Peters
Designer Ros Holder
Photographer Keiko Oikawa
Stylist and Illustrator Christine Leech
Production Director Vincent Smith
Production Controller Aysun Hughes

Quadrille
craft

www.quadrillecraft.com

First published in 2013 by
Quadrille Publishing Ltd
Alhambra House
27–31 Charing Cross Road
London WC2H 0LS
www.quadrille.co.uk

Text & project designs © 2013 Ros Badger
Photography © 2013 Keiko Oikawa
Design & layout © 2013 Quadrille Publishing Ltd

British Library Cataloguing-in-Publication Data
A catalogue record for this book is available from the British Library.

ISBN: 978 184949 308 6

Printed in China.